IMAGES
of America

HASTINGS-ON-HUDSON

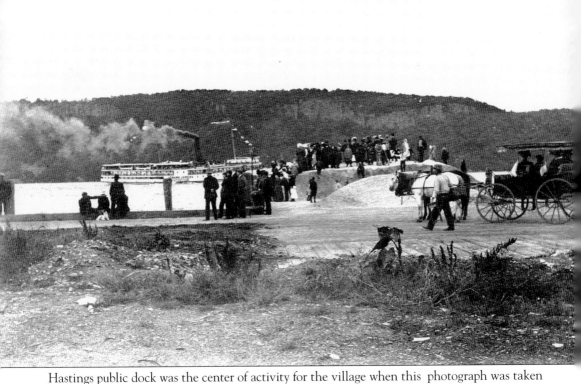

Hastings public dock was the center of activity for the village when this photograph was taken in 1909. Perhaps this steamboat is coming into the dock to discharge and take on passengers. A crowd is waiting and some people are just arriving by carriage. Traveling on the river by boat was the most popular way to transport goods and also an exciting family leisure activity.

IMAGES
of America

HASTINGS-ON-HUDSON

Hastings Historical Society

ARCADIA
PUBLISHING

Published by Arcadia Publishing
Charleston SC, Chicago IL, Portsmouth NH, San Francisco CA

Printed in the United States of America

Library of Congress Catalog Card Number: 2008921591

For all general information contact Arcadia Publishing at:
Telephone 843-853-2070
Fax 843-853-0044
E-mail sales@arcadiapublishing.com
For customer service and orders:
Toll-Free 1-888-313-2665

Visit us on the Internet at www.arcadiapublishing.com

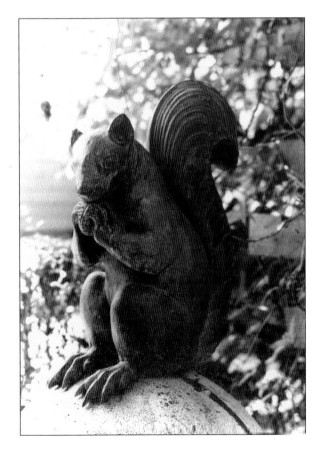

Generations of Hastings children have patted the bronze squirrel that sits at the southern footpath entry from Maple Avenue to Riverview Place. Its creator, Raffaele Menconi, lived to the west of the path from 1919 until 1942. He also created the eagle originally on top of the municipal building, which is now located on its portico. His best known works are the flagpole bases at the New York Public Library.

CONTENTS

ACKNOWLEDGMENTS

This book is the product of many individuals working together. We are grateful for the early planning and concept developed by Karolyn Wrightson and Barbara McManus for a Hastings waterfront history book; their work has been integrated into this completed project. The oversight of the society's archivists, Muriel Olsson and Beth Smith, has been important to the book's accuracy and breadth. The technological support of Fatima Mahdi has been essential in this digital age. The Book Committee of Paul Duddy, Maggie Favretti, Eileen Forbes-Watkins, Janet Murphy, Beth Smith, and Barbara Thompson has worked tirelessly and with exemplary cooperation under the enthusiastic and insightful leadership of its chair, Sue Smith. The story that we are telling in this book has been enhanced by Paul Duddy's contemporary photographs. We give special appreciation to Maggie Favretti who has contributed professional experience in matters large and small, from writing the introductions to points of grammar. Many thanks go to Rebekah Collinsworth, Arcadia's editor on this project, for her encouragement and guidance.

We acknowledge the photographic contributions of Lewis W. Hine, A. C. Langmuir, George Sackett, and Hanford C. Todd. Each of these Hastings residents used their cameras to capture the history of Hastings as it was being made. Their legacy became the heart of the Hastings Historical Society's collections and of this book. Also we recognize the many Hastings Historical Society members and village residents who have given their photographs, artifacts, and reminiscences so that Hastings's rich heritage continues to be preserved and can be shared with the wider community.

INTRODUCTION

The Hudson, more than any other river, has a distinct personality. With moods as various as the longings of human life she responds to our joys in sympathetic sweetness, and soothes our sorrows as by a gentle companionship . . . It often seems that there are in reality four separate Hudsons—the Hudson of Beauty, the Hudson of History, the Hudson of Literature, and the Hudson of Commerce. To blend them all into a loving cable reaching from heart to heart is the purpose of the writer.

Wallace Bruce (1844–1914), *The Hudson*
Quoted in Karolyn Wrightson, "On The Hastings Waterfront" Manuscript

Hastings residents have a different way of looking at maps. Whereas some might search for the compass rose, a Hastings dweller orients himself to the universe by locating the river. The defining presence in everyone's lives, from apple-blossom picnics watching lazy sails, to waterfront factory-whistle days unloading and processing and loading again, and to glowing orange mornings of the Palisades flashing by the Hudson Line commuters' windows, the Hudson River catches and reflects the light of our dreams.

Algonkian Weckquaesgeeks controlled the "Hudson of History" until the 17th century. After the 1609 voyage of Henry Hudson's *Half Moon*, they almost immediately started losing ground to the Europeans, and by 1682 had sold their land to Frederick Philipse. Philipse created a semi-feudal arrangement of tenant farmers beholden to him through rents. The tenants cleared the three hills of Hastings, planted grain and fruit orchards, milked well-fed cows, and fished from the river. They created their own economic and social bonds, and were only nominally neutral during the American Revolution. They crisscrossed the river at night to provision Washington's troops and also let pro-British Hessians walk right into a bloody ambush near Edgar's Lane. After loyalist Philipse forfeited his land, his former tenants were happy to purchase it.

In 1832, Joseph Anthony Constant bought from William Edgar the land upon which much of Hastings "village" was built. He owned a residence in the city and envisioned a countryseat, but when the expenses became too great, he divided his property near the waterfront into small commercial lots along Constant and Main Streets. Thus Constant began the standard practice in Hastings of subdividing large estates into planned neighborhoods—this time into what is now known as the business district. The lots began selling in the 1830s, with advertisements extolling Hastings's accessibility, industry, and beauty.

The Hudsons of "Beauty and Literature" began attracting New York artists and writers to Hastings early on. Washington Irving purchased land in Hastings in 1814, and then returned to the area in 1835, breathlessly eager to establish a permanent home for himself in the natural environment that

7

he believed cleansed and inspired his soul. Irving's Sunnyside, created with the help of Hastings artist George Harvey who drew the plans and served as construction foreman, became the model for other romantic artists and highly cultured New York society leaders to emulate.

Beginning in the 1820s, painters, writers, and tourists traveled up the Hudson River, the artists seeking picturesque stimulation, and the tourists wanting to see the sites they had read about or viewed on the canvasses for sale in the city. The Palisades caught and held the attention of many travelers, Nathaniel Parker Willis among them, who observed in his 1836 *American Scenery*, "this singular wall of rock, extending as far onward as [one] can see . . . The small sloops which lie along the shore, loading with building stone from its base, and an occasional shed . . . are the only marks of habitation it presents to the traveler's eye."

The building stone collected at the Palisades represented some of the earliest aspects of the "Hudson of Commerce," and native stone also provided Hastings with its first heavy industry. The quarry opened a vein of clear, white marble on one of the ridges in 1828. Immigrant laborers, mostly Irish, worked the stone, sending it down an inclined railway to the waterfront. A new subdivision called Uniontown provided small lots the local workers could afford.

Connections outside of Hastings, both social and commercial, continued to influence Hastings's development. Throughout the 19th century, Hastings attracted the rich and famous to its pastoral riverside beauty, and large country estates dotted the hillsides. The construction of the Croton Aqueduct and the addition of several more waterfront industries such as pavement and sugar factories, followed by chemical and cable factories, brought many more working families to town. The Irish-Americans were joined by Germans, and then Italians and Eastern Europeans. By the end of the century, over half of Hastings's population was foreign-born. They lived mostly on the south side of the ravine near the waterfront, a part of town referred to at times as the "foreign section." Crowded tenements housed multiple families without heat and running water, and families relied on their skills at gardening and frugal living. Many adults worked multiple jobs, which ranged from factory work to taking in boarders to running saloons to tending to the needs of the wealthy families in town.

Social life in 19th-century Hastings divided along socioeconomic class, though the lines broke down considerably in the 20th century. Jack Duddy recalls that the Condons, who cared for actress Billie Burke's home, had open access to the Burkeley Crest garden, which they freely shared with their friends. "The best scallions and tomatoes I have ever tasted came from there." Duddy and John "Butch" Condon also learned to ski on the Burke property. Progressive public schooling brought children of all backgrounds together in classes, on teams, and in clubs. A public library not only helped south-side children to find a warm place to study, it also provided a place where adults of diverse backgrounds could meet. The movie theater, pharmacy, ice cream parlors, and other village shops played a similar role. Men from every neighborhood volunteered for the firehouse squads and served together in village government. Shared crises such as the world wars, the Depression, blizzards, and fires also brought people together. During the Depression, those with money made work for the Hastings unemployed. Over 1,000 Hastings men and women of all backgrounds served in World War II. Their families shared the anxiety of waiting, the joy of many safe returns, and the pain of 31 losses.

The suburban desire for quiet streets, safe spaces for children to play and grow, plenty of trees, and spectacular views continued from the 19th into the 20th century. Two post-war building booms occurred in Hastings, as the easy commute into Grand Central Station made it an attractive site. The local population increased, contributing to a burgeoning social and artistic life. By the mid-1970s, the residential areas were built out, the waterfront was polluted, and Anaconda was closed. Yet people still move to Hastings. Attractive for its schools, the views, and its proximity to New York City, Hastings also has an unpretentious, slightly worn appeal attractive to artists, authors, and other independent thinkers. Poet John Masefield once wrote of Hastings, "It seemed to me that no one could be long unhappy beside a place so beautiful." The four Hudsons still blend together here, as do people of all kinds—comfortable in each others' company, and comforted by the river nearby.

One

ROOTS AND REVOLUTION

When Henry Hudson's Dutch East India Company *Half Moon* slid up the river in 1609, it brought Europeans into a relationship with native societies and lifeways thousands of years in the making. The Eastern Algonkian Weckquaesgeeks had already lived here for at least 6,000 years, eating deer, sturgeon, bass, and shellfish. They had a government based on communal decision-making led partly by women, and were members of the Wappinger Federation of tribes. While they had undoubtedly heard of Europeans before, and may even have seen some, it is unlikely that they had seen a vessel like the *Half Moon*. Some went out to meet it, and relations immediately soured when two were taken prisoner. Shackled, they jumped overboard and, as legend has it, swam from the Tappan Zee to Hastings, where they died. In revenge, the Weckquaesgeeks joined with others in an ill-fated ambush against the *Half Moon* on its return through Spuyten Duyvil.

In 1682, when Frederick Philipse offered guns, ammunition, wampum, cloth, clothing, and tools for what is now Dobbs Ferry and Hastings, the Weckquaesgeeks accepted. By 1697, Philipse owned most of the Bronx and Westchester and oversaw a vast commercial enterprise of fur trading and merchant shipping. Tenants farmed Hastings and paid their annual rent in cash and grain. Slaves at the Philipsburg mill ground the grain and Philipse then sent it off to feed slaves on plantations in the Caribbean. His ships returned packed with sugar and rum. Hastings-area tenants such as Peter Post and Adrian and Hendrick LaForge traded goods and services with each other as well.

During the American Revolution, Hastings tenants were squeezed between English troops and colonial rebels, their farms pillaged by both sides. Four tenant families, the Dyckmans, Posts, DeClarkes, and Fishers, purchased their farms during the 1785 sell-off of the loyalist Frederick Philipse III's "forfeited" lands, and the LaForge (newly named Lefurgy) descendants eventually bought some of their farm as well. While the one local skirmish that took place near Edgar's Lane may not have had a significant impact on its outcome, the American Revolution permanently changed the face of Hastings.

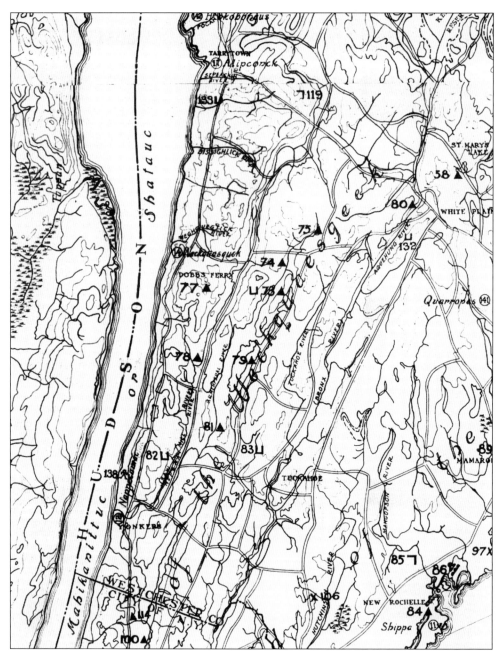

Native Americans had lived in the lower Hudson Valley for 6,000 to 10,000 years. They were Algonkians of the Delaware tribe, Mahikan subdivision. The local group was Weckquaesgeek, whose villages were in Dobbs Ferry and Tarrytown. For them, the river was the "Mahikanittuc"— meaning the river that flows two ways—and supplied them with shad, striped bass, sturgeon, eels, and oysters. Shell middens have been found in Hastings in the ravine under the Warburton Avenue Bridge. Stone tools and the flakes left behind in the making of tools have been found in Hastings over the years. Sites for encampment have also been identified. Some have been excavated and others destroyed by construction over the years. This map overlays some of the contemporary place names and roadways over the Native American territory.

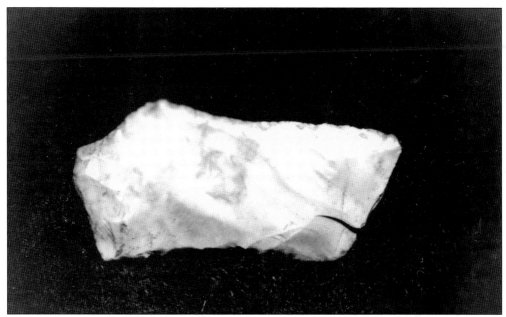

A scraper of reworked tan flint (above) found in the South Calumet Avenue area and a Brewerton Javelin Head of white translucent quartz (below) found in the Overlook Road area demonstrate a Native American presence in Hastings (2000–5000 B.P.). The relationship between the Native Americans and the Europeans was strained. In 1622, a Native American boy from Tarrytown went with his uncle to New Amsterdam to sell furs. A Dutch trader killed the uncle and took the furs. In 1641, the boy, now a warrior, avenged his uncle's death. This caused the Dutch governor, William Kieft, to launch "Kieft's war" on native villages from Albany to Montauk. Locally white settlers were killed in Yonkers and Eastchester. The war ended after the infamous Bedford Indian massacre on February 23, 1644, in which 500 Native Americans were slaughtered in their sleep.

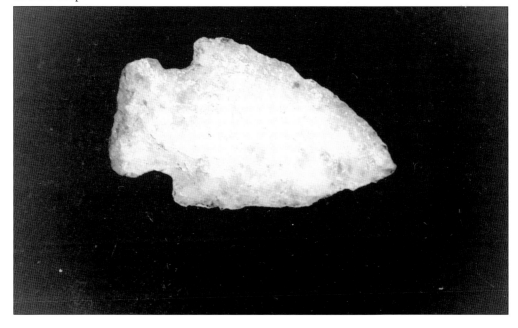

Text of the Indian Deed of Weghqueghe

All that tract of land situate, lying and being on the east of Hudson's river, beginning on the north side of the land belonging to the Younckers kill, or Wepperhaem, at a great rock called by the Indians Sigghes, and from thence ranging into the wood eastwardly to a creek called by the Indians Nepperha, and from thence along the said creek northerly til you come to the eastward of the head of a creek called by the Indians Weghqueghe, being the utmost bounds of the lands formerly bought of the Indians, &c, &c, attested by

Waramanhanck,	Esparamogh,	Anhook,
Maeintighro,	Mightereameck,	Sakissjenooh,
	Aghwarowes.	

The schedule of goods, &c, &c, paid by the grantee.

4 guns,	6 pair of stockings,	2 ankers of rum,
4 fathom of wampum,	10 bars of lead,	4 shirts,
4 blankets,	3 kettles,	2 fathom of cloth,
6 fathom of duffils	12 lbs. of powder,	1 adze,
	1 drawing knife.	

On September 6, 1682, Frederick Philipse made a formal agreement to trade guns, wampum, rum, and other articles with the Weghqueghe for land which included Hastings. (The spelling of this Native American group varies in published works.) This information is from Reginald Pelham Bolton's *The History of the Several Towns, Manors and Patents of the County of Westchester, Vol. I* in 1881.

Located on the Andrus Children's Center property on Broadway, marking the boundary between Hastings and Yonkers, Sigghes Rock is alleged to have been a Native American treaty site. It was used as a boundary marker by the Native Americans and also by the Dutch and English.

In 1609, Englishman Henry Hudson, employed by the Dutch East India Company, sailed past Hastings in the *Half Moon*, seeking a northwest passage to India and the Spice Islands. Hudson found the area "as pleasant a land as one need tread upon." When he reached the site of present day Albany, he realized the Hudson River would not lead him to the Far East. (Courtesy of the Hudson River Museum of Westchester.)

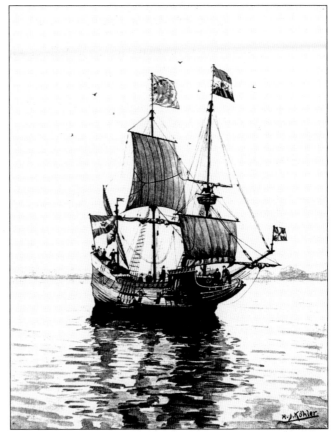

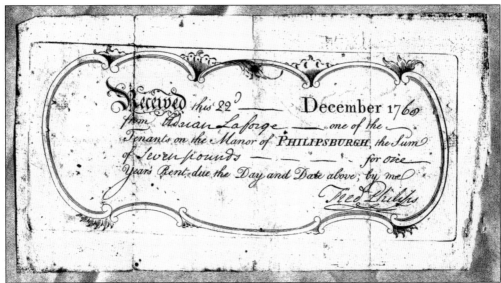

This 1760 receipt shows that Adrian LaForge paid one year's rent for his tenant farm on Philipse land. The first "Lefurgy" to be born in Hastings was James in 1761; he died in 1826. The last Hastings Lefurgy, Harry Preston, died in 1949. Their land extended at one time from the Hudson River to the Saw Mill River, and from Tompkins Avenue north to Villard Avenue.

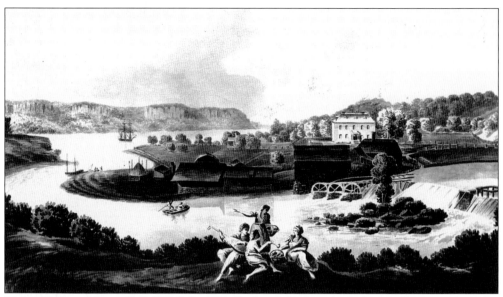

This is Philipse Manor Hall (1784). In 1681, Frederick Philipse built this small house where the Nepperhan (now the Saw Mill) River spills into the Hudson River. By the 1690s, Philipse lived in Yonkers and Manhattan, and Philipsburg Manor covered 92,000 acres, from the Harlem to the Croton Rivers and between the Hudson and Bronx Rivers. (Courtesy of Historic Hudson Valley, Tarrytown, New York, Gift of La Duchesse de Talleyrand.)

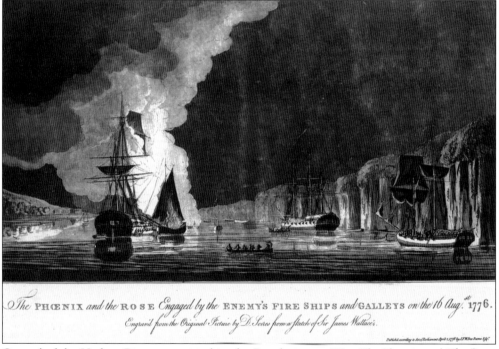

The PHŒNIX and the ROSE Engaged by the ENEMY'S FIRE SHIPS and GALLEYS on the 16 Aug.t 1776.
Engrav'd from the Original Picture by D. Serres from a Sketch of Sir James Wallace's.

Control of the Hudson River was critical in the Revolutionary War. *The Phoenix and The Rose, August 6, 1776,* a 1778 aquatint by James Wallace and Dominic Serres, shows two British ships being prevented from passing beyond Yonkers. (Courtesy of I. N. Phelps Stokes Collection, Miriam and Ira D. Wallach Division of Art, Prints and Photographs, the New York Public Library.)

During the Revolutionary War, with the British occupying Manhattan and the Continental Army holding West Point, Westchester became contested neutral territory. While Philipse remained a loyalist, his tenant farmers fought on both sides. The Neutral Forge on Broadway served all comers. This photograph was taken prior to 1907, before the building was enlarged into a private residence.

This large black walnut tree on the Draper property, photographed in the 1920s, stood just south of the Neutral Forge and was nicknamed the "Treaty Tree." Legend says that a Revolutionary War treaty was signed under it, but nothing more is known. The tree died in 1926, leaving its progeny on the property.

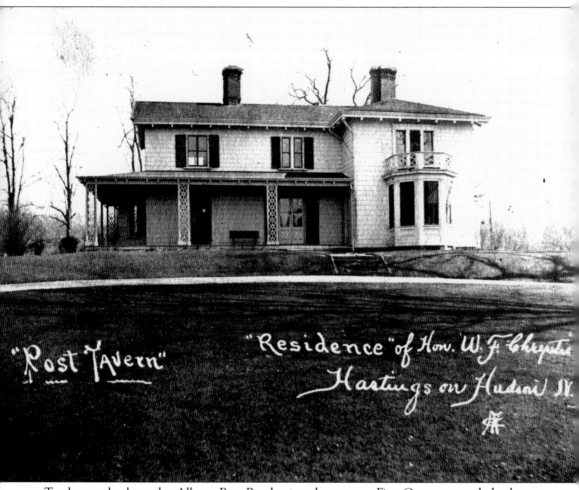

"Post Tavern"

"Residence" of Hon. W. F. Chrystie Hastings on Hudson N.Y.

To the north along the Albany Post Road, near the present Five Corners, stood the home and tavern of Peter Post. Later additions were made to the house, which became Albert Chrystie's home; in the mid-20th century, the property became two apartment houses and a local supermarket. Post holds a special place in Hastings history and lore. As tavern proprietor in "neutral" territory during the Revolutionary War, Post served both British officers and Continental soldiers. He was able to overhear conversations about British strategy and passed the information to George Washington's troops. The result was an ambush of Hessian soldiers just north of his tavern, Hastings own Battle of Edgar's Lane. Post received a severe beating from the British for his patriotic role.

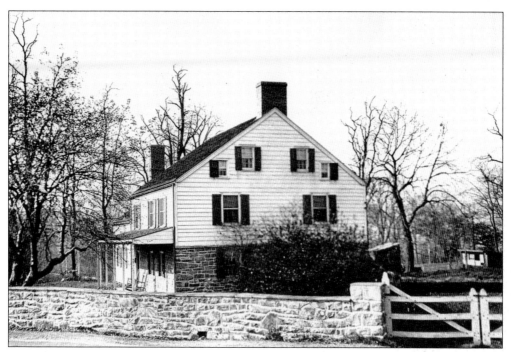

One of Hastings's oldest remaining buildings, the Dyckman House, (originally called Brown's Tavern), sits near the southern boundary along the Albany Post Road. Its design remains faithful to homes of the Revolutionary War era. Evert Brown married Jemina Dyckman in 1782; their descendant Julia Dyckman lived there and married John E. Andrus. They created the present Andrus Children's Center on family property and Andrus on Hudson on the Longue Vue land.

This 1775 house was on the Dyckmans' 200-acre farm. The Currys bought the house, by then much enlarged, in 1865 and moved the family goods by sloop from New York City to the Hastings dock and by oxcart to the house. Their daughter Sarah became a medical doctor, practicing in Yonkers and Hastings. Their son Francis F. was a Town of Greenburgh justice and was known to all as "Judge Curry."

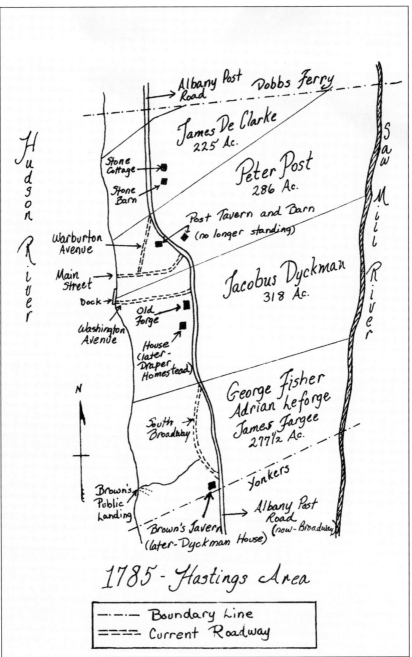

Hudson River

Saw Mill River

Albany Post Road — Dobbs Ferry

James De Clarke 225 Ac.

Peter Post 286 Ac.

Stone Cottage

Stone Barn

Post Tavern and Barn (no longer standing)

Warburton Avenue

Main Street

Dock

Washington Avenue

Jacobus Dyckman 318 Ac.

Old Forge

House (later-Draper Homestead)

George Fisher Adrian Leforge James Fargee 277½ Ac.

N

South Broadway

Brown's Public Landing

Yonkers

Albany Post Road (now-Broadway)

Brown's Tavern (later-Dyckman House)

1785 - Hastings Area

----- Boundary Line
===== Current Roadway

Frederick Philipse encouraged settlement by offering good terms to tenants. Beginning in 1702, there were four tenant farms in Hastings. The succession of tenancy is shown on this map of the Hastings area, which is based on the Commissioners of Forfeiture Map. In 1785, as a result of the colonists winning the Revolutionary War, the commissioners were convened to dispose of Tory land, which they sold at public auction, often to former tenants. Largely self-sufficient, the farmers raised wheat, corn, and cattle and shipped their goods to market on the small sloops that plied the Hudson. A rum still operated near the dock—Hastings's first waterfront industry. (Redrawn by Denise Klein from the original for the *Hastings Historian*, Fall 1998.)

Two

WATER AND STONE, STEAM AND SUGAR

The Hastings waterfront is where prodigious natural resources and the latest industrial and transportation technologies met. Three Hastings residents were among those who brought this interaction about: George Harvey, Eide Hopke, and Frederick Zinsser.

Harvey, a British-born painter and engraver, purchased a sizable estate for $1,200 in 1834 that included Philip Van Brugh Livingston's white marble quarry, opened in 1828. The quarry employed Irish immigrants who lived mainly in Uniontown (see pages 116–117). By 1838, when Harvey sold a strip of his land to New York City for the Croton Aqueduct, the business was so firmly established that the city had to build a tunnel under the aqueduct to protect the route of Harvey's inclined railway to the waterfront. In 1846, Harvey sold most of his property for $10,000 to pay for the publication of his book of engravings from watercolors including *Hastings Landing*. Pure Hastings marble built well-known buildings in Hastings, Manhattan, Richmond, and Charleston until the Civil War, when financial troubles and injudicious blasting undermined the operation.

After the train came through in 1849, new businesses grew. Henry Kattenhorn used the latest steam method for processing sugar, beginning in 1853. He later joined with the Hopke brothers, of whom Eide retained the largest share of the Hudson River Steam Sugar Refinery. The disastrous fires of the winter of 1875–1876 put Hopke out of business. Most of Hopke's workforce left town, but some eventually found work in the Hastings Pavement Company, known as the "fog works" for the acrid dust it spewed into the air. Nonetheless, it employed many local residents, making its distinctive hexagonal pavers until 1944.

Zinsser's chemical company produced tannic acid, wood alcohol, photographic chemicals, and dyes. By 1917, Zinsser employed 200 people and was protected by 200 soldiers bivouacked across the street. Colonel Zinsser was the model of a paternalist employer, providing pensions based on his word, care for ill employees, and company outings. During World War I, Zinsser opened his garden for public use. Among the many residents devoted to Hastings and its people, these three connected local resources and global commerce to help Hastings prosper.

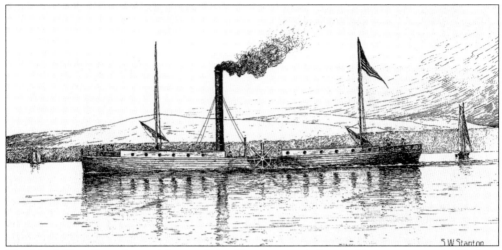

The *North River Steamboat*, nicknamed the *Clermont*, made her maiden voyage up the Hudson River on August 17, 1807. It was a 150-mile trip from New York City to Albany, done in 32 hours northbound and 30 hours south at an engine speed of five miles an hour. Robert Fulton, the boat's designer and builder, was well pleased. (Stanton, Samuel Ward. *Flyers of the Hudson.* Lunenberg, VT: Stinehour Press, 1965.)

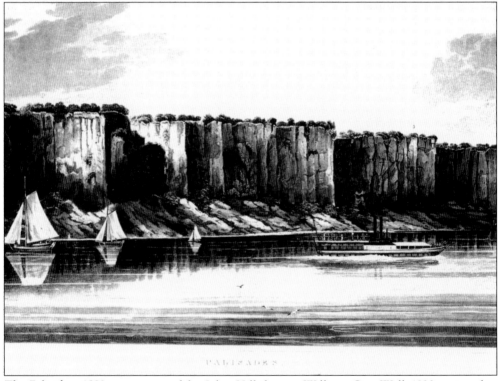

The Palisades, 1823 was engraved by John Hill from a William Guy Wall 1820 watercolor. Journalist Nathaniel Parker Willis referred to the Palisades as "the first feature of the celebrated banks of the Hudson . . . this singular precipice varies in height from fifty to two hundred feet, and presents a naked front of columnar strata," (Collection of The Hudson River Museum, Yonkers, NY. Gift of Miss Susan D. Bliss, 66.27a.)

The Rowley house with its magnificent river views was built of local stone by 1807 and has since been much enlarged. Susan S. Rowley bought the 33-acre property at a foreclosure auction in 1846. The family planted a vineyard on most of their land, all of the current Pinecrest neighborhood, producing a Rowley Brothers wine that was well known and in high demand.

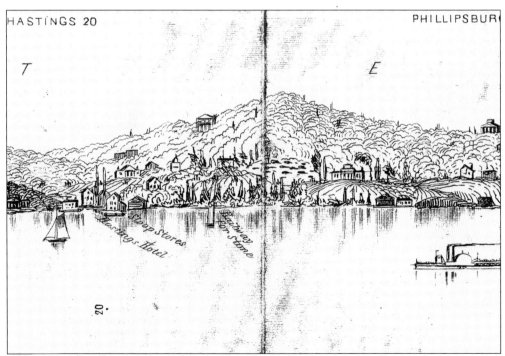

Steamboat travel had become an attractive leisure activity as well as serving for transport of freight. This sketch, made around 1847, is the Hastings section of a panorama by William Wade of the full length of the Hudson River that was sold on steamboats traveling to Albany. Tourists aboard were eager for information about the areas that they were seeing along the river.

SLOOP

CENTURION,

CAPT. P. H. HILLMAN,

Will commence her Regular Trips between

HASTINGS
AND
NEW YORK

Monday, March 7th, 1859.

Leave Hastings, every Monday, at 10 A. M.,

and New-York every Wednesday at 12 M.

FROM FOOT OF LAIGHT STREET.

All kinds of Freight Taken

on moderate terms, and delivered in good order.

☞ This Sloop may be chartered on Friday or Saturday for an extra trip.

For further particulars inquire of J. M. Schlosser, or T. Archard.

About 200 sloops operated on the lower Hudson River before the invention of the steamboat. Even though steamboats captured the heavy freight and passenger business, the number of sloops dramatically increased to around 500 because they became the market boats, carrying lighter goods and the mail to the growing population. Sloop captains carried local farm produce to New York City markets and returned bringing dry goods to residents. Capt. P. H. Hillman, of the sloop *Centurion*, lived in this house on Maple Avenue, conveniently located near the village dock and typical of village houses. This 1929 house photograph is from the Hastings Historical Society's large A. C. Langmuir collection. Langmuir, a chemist by profession, made a hobby of photographing the village from 1922 through 1940, creating an invaluable pictorial record.

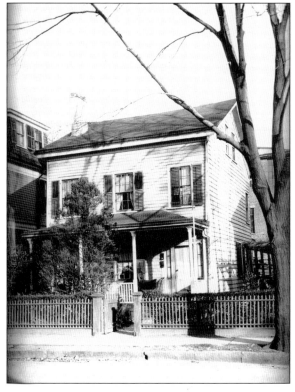

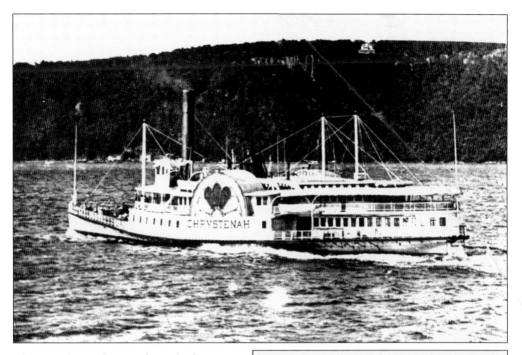

The steamboat *Chrystenah* was built in Nyack in 1865 and operated until 1913 between lower Manhattan and the river villages as far north as Peekskill, and also in Long Island Sound. The ride to Manhattan cost 35¢ and took about 90 minutes. Early steamboats such as the *Clermont* used both sail and steam, but technology quickly developed so steam power alone was adequate. Although steamboats were used throughout the nation's rivers and coasts, the passenger boats on the Hudson River were rated the fastest. Steamboat travel became a competitive business on the river, with families eager for day trips and many seeking the thrill of fast transportation. The elegant overnight boats to Albany had grand staircases and two-story-high salons. Watching and waving to the passing parade of steamboats became a popular source of entertainment.

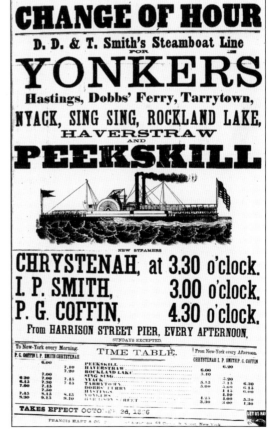

CHANGE OF HOUR

D. D. & T. Smith's Steamboat Line
FOR

YONKERS

Hastings, Dobbs' Ferry, Tarrytown,
NYACK, SING SING, ROCKLAND LAKE,
HAVERSTRAW
AND

PEEKSKILL

NEW STEAMERS

CHRYSTENAH, at 3.30 o'clock.
I. P. SMITH, 3.00 o'clock.
P. G. COFFIN, 4.30 o'clock.

From HARRISON STREET PIER, EVERY AFTERNOON,
SUNDAYS EXCEPTED.

TIME TABLE.

To New-York every Morning.				From New-York every Afternoon.		
P. G. COFFIN	I. P. SMITH	CHRYSTENAH		CHRYSTENAH	I. P. SMITH	P. G. COFFIN
6.00			PEEKSKILL			
	7.10		HAVERSTRAW			
	7.20		ROCKLAND LAKE			
			SING SING	6.00	6.20	
7.00	7.00	7.45	NYACK	5.40		
6.30	7.30		TARRYTOWN		5.20	
6.45	7.45	7.45	DOBBS' FERRY	3.15	3.15	6.30
7.00	7.50		HASTINGS	3.00	5.00	6.15
7.45	8.15	8.15	YONKERS		4.15	6.00
8.30	9.15	9.10	HARRISON STREET	4.25	4.10	
				3.30	3.00	5.30
						1.30

TAKES EFFECT OCTOBER 2d, 1876.

LET US KNOW

FRANCIS HART & CO. P...

George Harvey, an English landscape artist, came to Hastings in 1834 for his health. He bought 50 acres from Philip Van Brugh Livingston of Dobbs Ferry, including the marble quarry and two docks, land extending from Washington Avenue to Nodine Street and from Draper Park to the Hudson River. Harvey never operated the quarry himself but leased it to others. (Collection of the New-York Historical Society.)

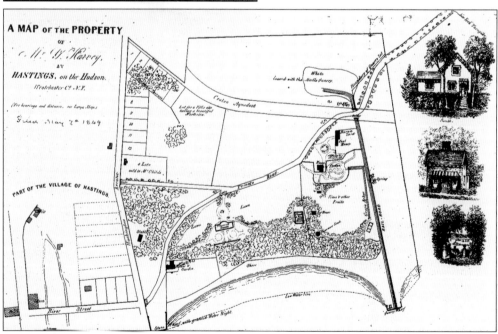

A map of Harvey's Hastings estate, filed with Westchester County in 1849 soon after it was bought by Henry Wilson, shows the locations of a decorative stone cottage, gardens, orchards, a vineyard, an icehouse, extensive lawns, and forested areas. This is one of the earliest maps that contains the words "Hastings, on the Hudson."

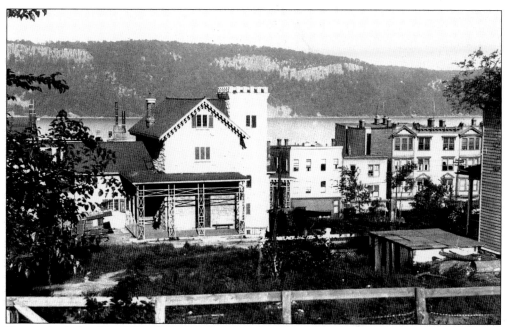

Harvey built his "castle" to his own design and with marble from his own quarry. An 1843 magazine article about houses in the Hudson Valley called it a "gem." His talents were appreciated by Washington Irving when Harvey assisted him in the design and building of his Irvington home, Sunnyside. This 1924 photograph was taken by A. C. Langmuir from the Old Croton Aqueduct after new buildings had reduced the river views.

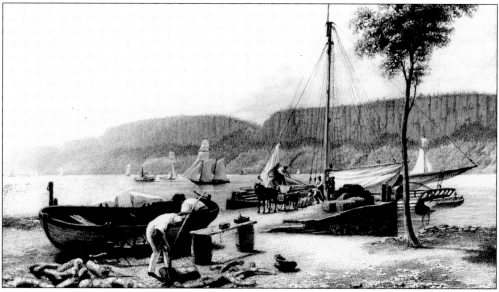

Harvey traveled throughout North America before settling in Hastings. He did miniature portraits for society clients and later sketches and watercolors of the local landscapes. This watercolor, *Afternoon - Hastings Landing, Palisades Rocks in Shadow, NY* from around 1836, shows the active Hastings dock. By 1846, Harvey had sold his property and returned to his home country England with hopes of success for his atmospheric landscapes. (Collection of the New-York Historical Society.)

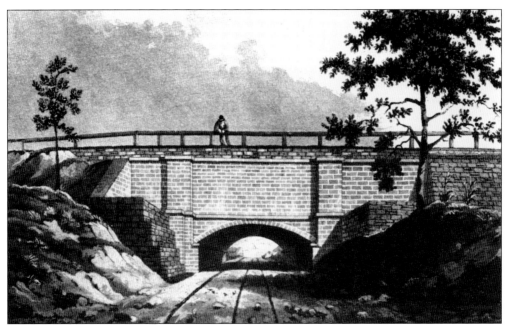

The Old Croton Aqueduct, built in the 1840s to bring clean country water to Manhattan, passes through Hastings, north to south. This 1843 print shows the arch over which the aqueduct crosses the narrow gauge railway that linked the marble quarry with the river docks. The railroad's path has since become part of the village's trail system. (F. B. Tower, *Illustrations of the Croton Aqueduct*.)

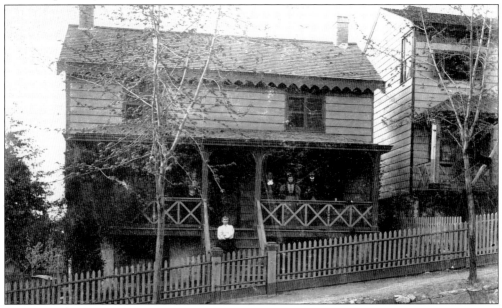

Many Irish immigrants were employed for the 41-mile long Old Croton Aqueduct project. Some remained in Hastings and lived in modest houses, similar to the one pictured, around Uniontown and Washington Avenue. The area lots were advertised as commanding "untiring views of the river the Village is fast rising into importance by its own native attractions . . . [and] is fast filling up with neat and comfortable dwellings by an industrious and intelligent community."

In 1857 the quarry business included a marble mill, a coal house, machine and stone cutting shops, a lime kiln, three waterfront acres and 50 to 100 employees. The quarry closed in 1871 after the Draper family sued and part of the Draper property collapsed into the quarry, nearly killing nine workers. The quarry later became a private garden (as shown here), then the village landfill, and now may become a public park.

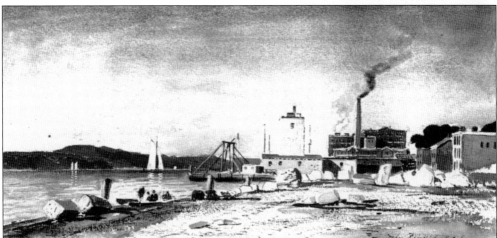

The marble quarry and the Hudson River Steam Sugar Refinery, in the distance, were both active on the waterfront. Hastings marble built Marble Collegiate Church in Manhattan, the Customs House in Charleston, and several fine local homes. (Samuel Colman, *Quarry Works, Hastings on Hudson*, 1850–1920. Gift of Maxim Karolik for the M. and M. Karolik Collection of American watercolors and Drawings, 1800-1875. Photograph © 2008 Museum of Fine Arts, Boston.)

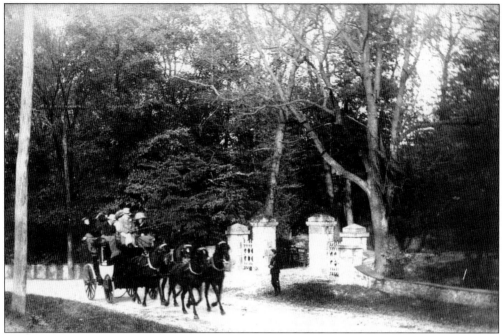

The "Tallyho," a four-in-hand coach with liveried footmen, offered an elegant trip between Manhattan and the Ardsley Country Club. Horses wearing red and yellow plumes were changed near the northwest corner of Washington Avenue and Broadway. In 1900, it passed the Moore Estate driveway, now Burnside Drive. Local horse traffic used the pump and watering trough at the Five Corners, donated by the Chrystie family in 1878.

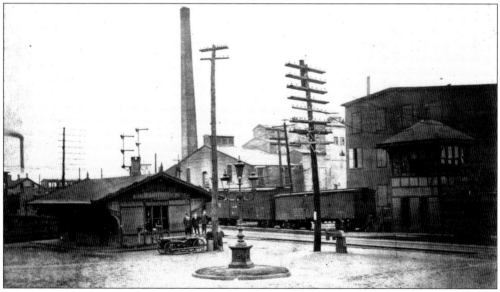

The Hudson River railroad opened in 1849 and dramatically altered the Hastings waterfront and transportation in the Hudson River Valley. The natural riverbank was filled in for the tracks. A sloop trip to Albany required four to seven days, depending on tides and wind. The steamboat trip was eight hours, and the train halved that to four. This 1900 photograph was taken after the advent of electricity in the 1890s.

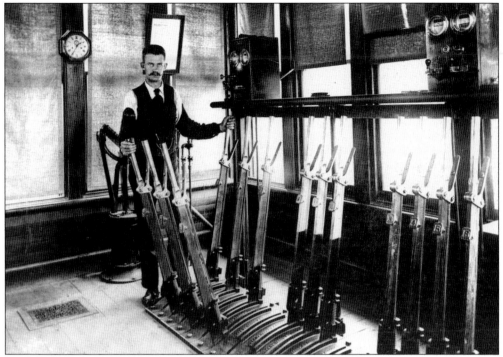

The Railroad Switch Room is in the two-story building (on the previous page) on the second floor surrounded by windows. The levers on the floor were manually operated and controlled the crossover switches. The two boxes against the windows were block occupancy indicators, giving information about occupancy in a defined length of track. This photograph is undated but is probably about 1900.

In 1869 the Putnam Rail Line opened to the east, providing passenger and freight service between New York City and Brewster with connections east and west. It also served Mount Hope Cemetery. A teahouse beside a pedestrian footbridge over the Saw Mill Parkway, a small convenience grocery store, and a tavern on lower Mount Hope Boulevard supplied travelers. The "Put" closed in 1982, and its land became a public footpath.

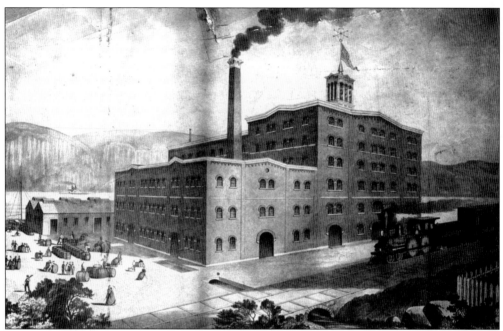

The Hudson River Steam Sugar Refinery was the first large waterfront manufacturing industry. Its location was critical between the river, for receiving raw Cuban sugar, and the railroad, for shipping refined sugar. The ravine provided fresh water to make the refinery's steam. Henry Kattenhorn, an experienced sugar boiler from Manhattan, built this refinery in 1853. With thousands of German immigrants available, Kattenhorn, a German immigrant himself, hired many to work in his business, shown in this 1874 lithograph. In 1851, Kattenhorn built four identical houses for his mill superintendents in the popular Gothic Revival style. The refinery workers had shanty housing along the waterfront. The refinery provided jobs and spurred economic growth throughout the village. By 1861, German Lutheran Church had begun with a traveling preacher; a church building followed in 1887. This became St. Matthew's Lutheran Church on Main Street.

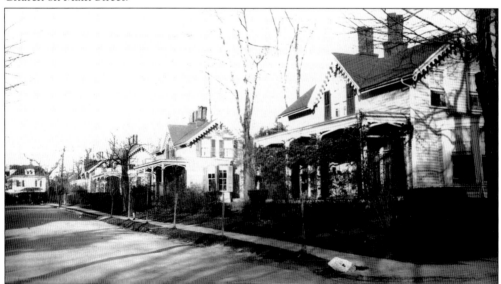

In 1861, Kattenhorn entered a partnership with Eide F. and Mathias Hopke, German immigrant grocers. By 1872, Kattenhorn had died, and the business name became the Kattenhorn, Hopke, Offerman and Doscher Refinery. Soon afterward the Hopke brothers split, with Mathias building a small refinery of his own at the southern end of the waterfront. This photograph shows Eide, who after village incorporation in 1879 became a village trustee. Eide built this fine stone residence, named Olinda, which means "beautiful" in Portuguese, which still stands on Hopke Avenue. The house, on a seven-acre estate, had a grass tennis court, gardens, a stable, and a formal entry from the Albany Post Road. It is fondly remembered for its later days as the Grant Studio of Dance, where many local children, wearing white gloves, took their first ballroom dance lessons.

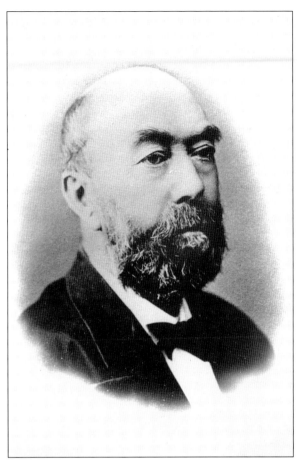

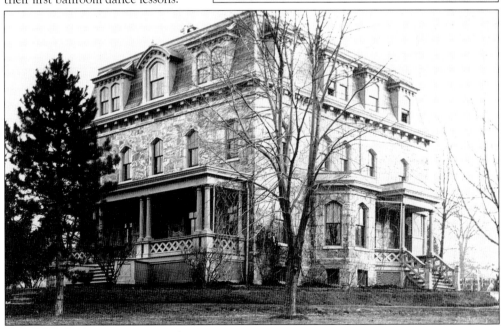

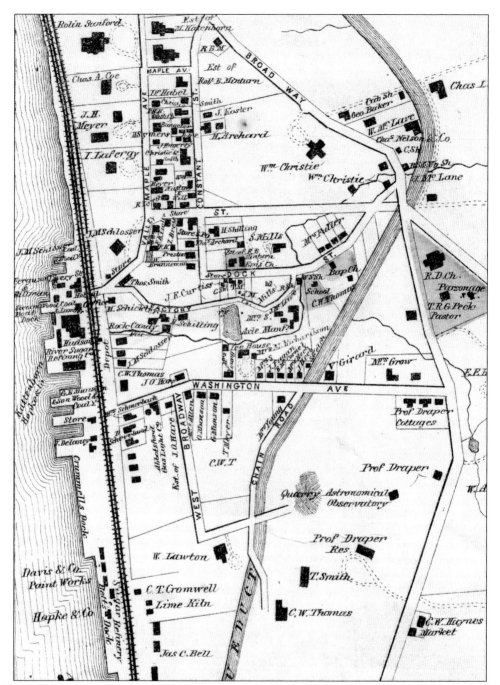

The 1872 Beers Atlas shows clearly the impact of the railroad. The ravine where the early industries had been located no longer had access to the Hudson. In the next two decades, numerous industries sprang up west of the tracks on landfill. Cromwell's Dock served the marble quarry. A number of coal and lumber yards were nearby. The most important industry remained the Hudson River Steam Sugar Refinery. Later street name changes reveal that Constant Street became Warburton Avenue, Dock Street became Main Street, Valley Street became the north end of Southside Avenue, and West Broadway became Ridge Street.

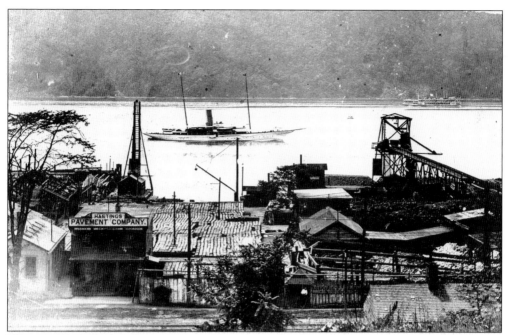

The community had its first great tragedy on the night of December 26, 1875, when the Hudson River Steam Sugar Refinery burned to the ground. More than 200 workers lost their jobs, out of a total population of 1,300. Shopkeepers lost business, and the school laid off a teacher. By the 1880s, the Hastings Pavement Company opened on the refinery site, and National Conduit and Cable started business on the waterfront.

This photograph, around 1910, shows the Hastings Pavement Company on a company outing. The company's paving stones were a trap rock and asphalt product, molded into hexagons, squares, and rectangles, which were non-absorbent and weatherproof. They can still be seen along the sidewalks of New York City's Central Park, Battery Park City, and Liberty Plaza on Ellis Island, as well as many Hastings sidewalks and patios.

In 1896, Frederick Zinsser purchased part of the Minturn property for his family. The remainder became Riverview Manor. The Zinsser house had been built in 1828 by Joseph A. Constant, who sold the 30-acre estate in 1850 to Robert Minturn, an owner of the Flying Cloud, the world record holder as the fastest clipper ship from New York City to San Francisco. In the 1960s, the property became village ball fields and community gardens. The Zinsser Chemical Company came to the southern waterfront in 1897, manufacturing specialty chemicals and dyestuffs. In 1910, Zinsser hired William Steinschneider, a professional chemist recently graduated from Columbia University. Steinschneider worked with Zinsser for 24 years as general manager and vice president, lived in the village, married the granddaughter of Jasper F. Cropsey, and served as village mayor from 1934 to 1945.

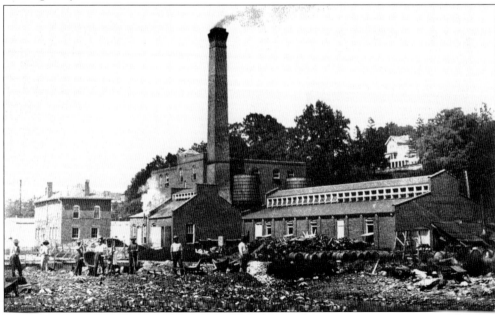

The 1910 photograph at right shows two of the three Babcock and Wilcox boilers used to power the Zinsser factory. The pile of coal to the left is ready to be shoveled in. During World War I, the Zinsser Chemical Company was a vital supplier for the military effort. The photograph below is the Ethelene Plant for alcohol evaporation at the Edgewood Arsenal, a special federal government installation at Zinsser Chemical Company that was prepared to make mustard gas for the World War I effort. Zinsser had invented a simplified formula for making the gas that could be manufactured in three locations across the country. The Hastings Arsenal was protected by its own military guard and hospital detachment.

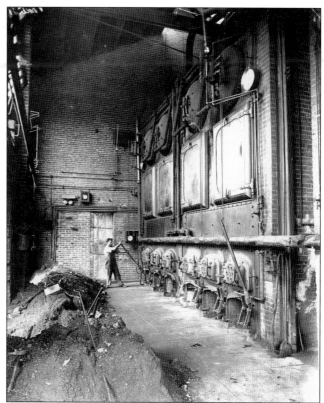

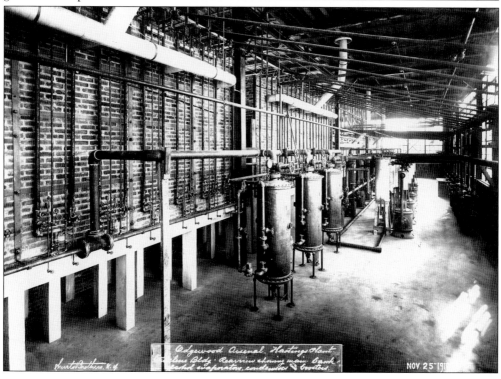

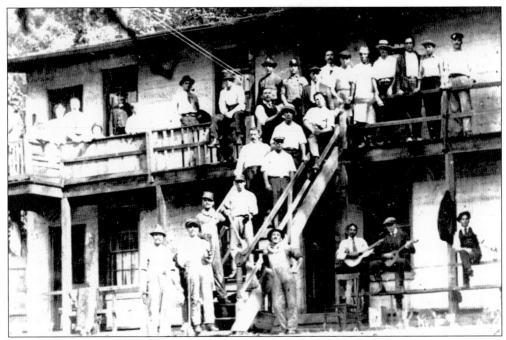

Cotlet's Boarding House was an important ravine institution, providing inexpensive and rudimentary housing for many of the waterfront workers. It stood to the east of the pond under the Warburton Avenue Bridge. Owner Mary Cotlet earned the nickname "Crazy Mary" for her eccentricities. On summer evenings, the residents would gather to relax, play music, and sing. The Cotlet family is in the upper left corner.

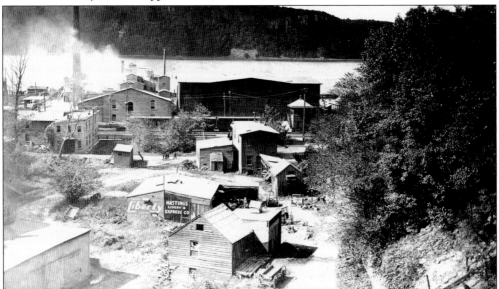

This is the ravine in 1900 looking to the west. The jail is the small free-standing building to the center left; across the tracks is the Hastings Pavement Company to the left, National Conduit and Cable in the center, and the railroad's switch room to the right. The foreground is now the Zinsser Plaza commuter parking lot and across the tracks to the west is the Anaconda Wire and Cable Company site.

Three

THE GROWING VILLAGE

When Hastings incorporated in 1879, its population was just over 1,000 people, and much of the area outside of the business district was still farmed. Most people who commuted into Manhattan went on steamboats, which were cleaner and quieter than the train. A steam freighter called the *Raleigh* stopped to provide goods for local businesses every weekday.

By 1900, Hastings had gone through considerable change. It had two fire companies, a full-time policeman (Edward J. Murray), a number of factory whistles to keep time, the Fraser Free School, almost no farms, and ordinances such as those banning nude swimming between 5:00 a.m. and 8:00 p.m. and the slaughtering of animals between April 1 and November 1. There was a bridge over the ravine, the trolley extended out Farragut Avenue, and Constant Street was about to be paved and renamed Warburton Avenue. There was a public telephone, and village president Frederick Zinsser had just phased out the town lamplighter's job in favor of electrified lamps.

Over the next decades, Hastings grew as thousands of immigrants were attracted to work in the mills. The Farragut School was built, a public library founded, another fire company added, and by 1930, there were three policemen, John "Spot" Donegan, Walter "Puss" Cronell, and George Murray. Most youths attended Foster Hastings's movie theater once or twice a week, and there were more unforgettable people, whose names are so closely associated with the life of the "village" as to be institutions themselves. Doc Todd's Pharmacy provided everything from medicines to ice cream sodas to the telephone and postcards. Joe Boulanger's barber shop was the news center for men of all backgrounds, bus driver "Happy" Halloran thought of all the school children as his own, and Gus Bruning made the best ice cream in town.

When the village needed protection and support, there were plenty to take on the task. Over 1,000 young men and women served in the armed forces, and others pitched in at home. By the end of World War II, Hastings Village had developed the character it still retains today.

School crossing guard wpa

37

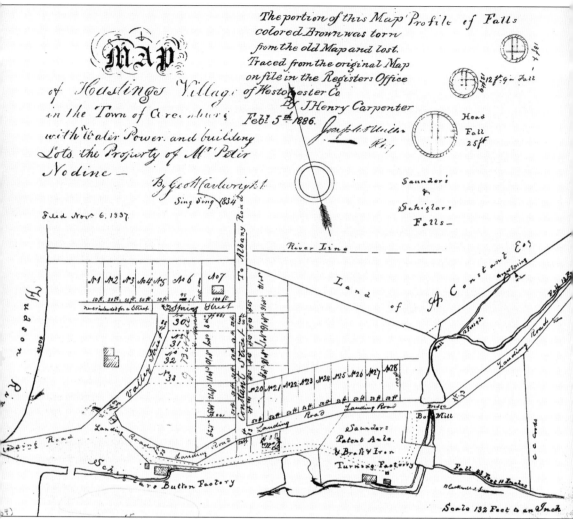

All along the Hudson, developers in the early 1880s bought former tenant farms and laid out streets connecting the Albany Post Road to the Hudson River. This 1834 map, filed by Peter Nodine in 1837, shows small lots that form the central business district today: Constant Street (now Warburton Avenue), Landing Road (now Main Street), Spring Street, and Valley Street (now Southside Avenue). Broadway is east of this map. The bridge on Landing Road is where a bank stands today. Residents obtained their drinking water from a large spring there. Where two streams merged in the ravine, damns were built to supply power to water wheels that operated a bone mill, Saunders Patent Axle, Brass and Iron Turning Factory, Schiglar's Button Factory, and other small factories.

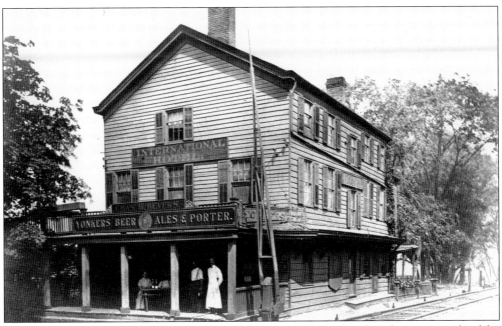

Proprietor Charles H. Bevers's International Hotel sat near the railroad on the western side of the tracks. It had a prime location for business, at the corner where Landing Road and Valley Street met to continue down to the "Landing Dock." The International Hotel as well as the Tammany House saloon and hotel to the west of the tracks at Washington Avenue were demolished in 1912 to make way for the expansion of National Conduit and Cable. In 1890, not only were beer and ale on the International Hotel menu, but also there was a tea service available. This photograph shows the Bevers family in the rear garden amidst trees and trellis.

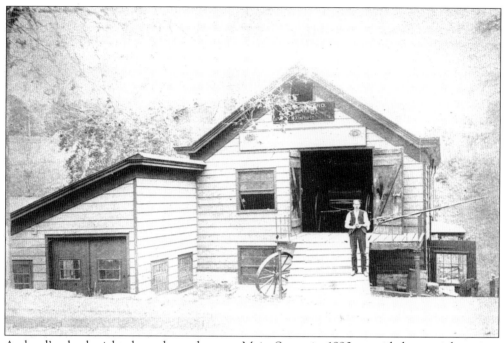

Archard's wheelwright shop, shown here on Main Street in 1890, provided essential services during the era of horses, buggies, and carriages. The shop stood beside the stream coming into the ravine right above the pond that powered businesses in the ravine. Later it was the site for both the past and present village community centers.

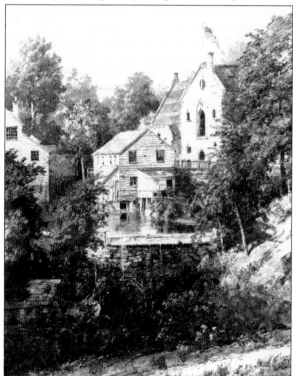

This watercolor by Jasper F. Cropsey, a Hudson River School painter, is *View of the Ravine from the Artist's Residence*. The artist's home and studio, on Washington Avenue, look to the north. When this work was completed in 1891, the dammed pond was providing power for the ravine industries. The blacksmith shop is behind the pond and the Fraser Free School to the right. (Collection of the Newington-Cropsey Foundation.)

This 1834 home on Albany Post Road has not changed much over the years. The house and its outbuildings were built by George P. Baker, a cabinetmaker, who arrived in Hastings in 1830. Trained as a master craftsman in France, Baker provided coffins as well as furniture. In later years, the first floor of the house became a funeral parlor. Baker also served as mayor from 1882 to 1884.

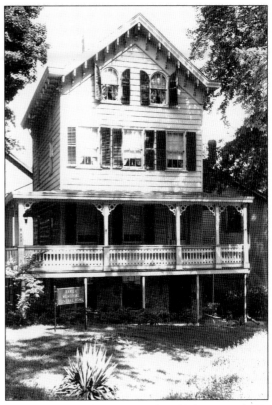

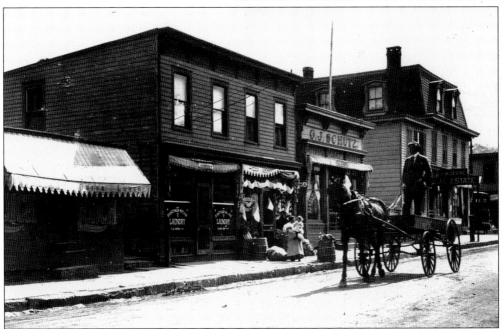

This photograph captures the east side of Warburton Avenue, looking south toward Main Street in 1906, including, from left to right, Halley's Quick Lunch, Hastings Steam laundry, C. J. Schutz National Meat Market, and R. M. Devine Real Estate.

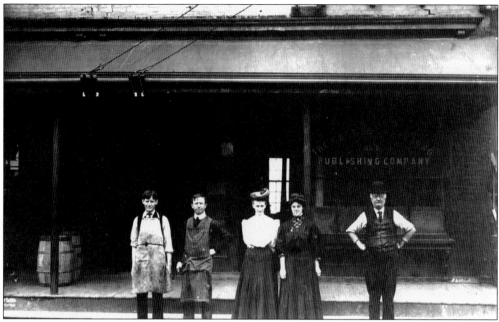

The Hastings Printing and Publishing Company was at 575 Warburton Avenue on the western side when this photograph was taken in 1907, showing, from left to right, John McLave, Edward W. Henry, Margaret McConnell, Amy Britton, and Will Fowler. This storefront was typical of the village shops that lined both Warburton Avenue and Main Street at that time.

Coming to Hastings in 1898, Hanford Todd was the local pharmacist and an amateur photographer who captured village life for his postcards of Hastings scenes. A soda fountain and a telephone were the most popular attractions at "Doc" Todd's shop. He was the first village historian, collecting any Hastings artifacts that he could find. Todd's drug store building still stands at the corner of Main Street and Warburton Avenue.

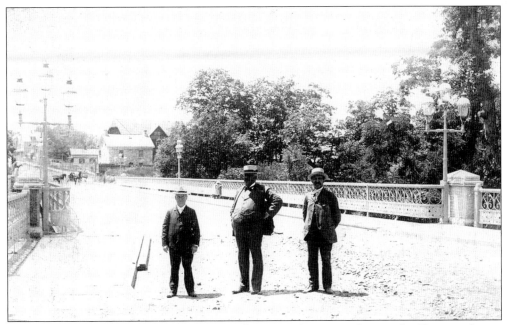

The opening of the Warburton Avenue Bridge in 1899 was a milestone for Hastings. It was celebrated with an opening day parade and an evening lantern parade. Then vehicles could go directly to Yonkers from the center of the village and local people had an easy walk south, over the ravine. By 1900, the Yonkers trolley was added to the route. Shown are, from left to right, unidentified, William Ward, and Ward Tompkins.

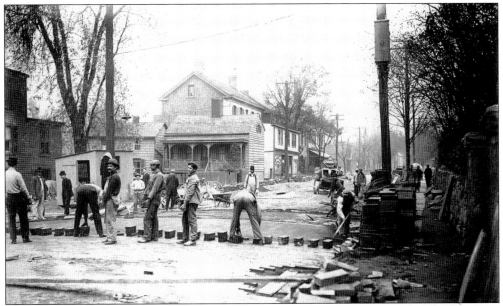

In 1905, Warburton Avenue at the intersection with Spring Street (looking north in this photograph) was upgraded with Hastings Pavement Company paving blocks, probably to accommodate automobiles. On the right is the stone wall and entry pillars for artist Carl Brandt's home, later the Veterans of Foreign Wars building. In the center right is an early work vehicle. The Limekiller house is in the background.

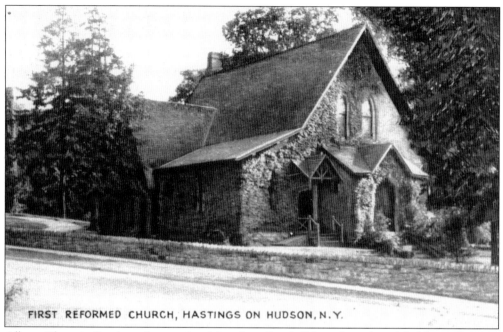

FIRST REFORMED CHURCH, HASTINGS ON HUDSON, N.Y.

Albert Chrystie lived to the north of Landing Road (Main Street) and held small prayer meetings in his carriage house. He and 11 other residents established the Dutch Reformed Church in 1850. Isaac and Jane Lefurgy donated the land, and an initial design was sketched by Alexander Jackson Davis, the architect of Lyndhurst in Tarrytown. Chrystie became the first village president after the 1879 village incorporation.

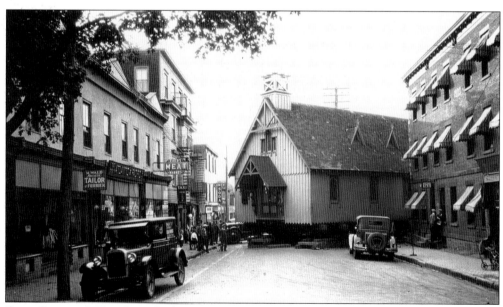

Grace Episcopal Church was built in 1868 on the north side of Main Street, at the front of what is now Boulanger Plaza parking lot. In 1931, the church began its journey up Main Street to its present location at Five Corners. The Great Depression was at its height, and according to legend, the street was blocked for several days when the moving company went bankrupt.

44

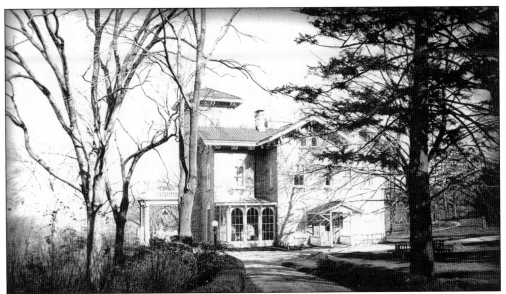

In 1855, Jehiel Read bought land from Jane and Isaac Lefurgy. He built this house, a large stone stable, and a greenhouse. Burnside Drive is the location of the old driveway. Edward C. Moore bought the 30-acre property in 1890 as a summer home. Moore was a prominent silversmith for Tiffany and Company. In 1926, the Homeland Company purchased the whole property and created the Shado-lawn neighborhood.

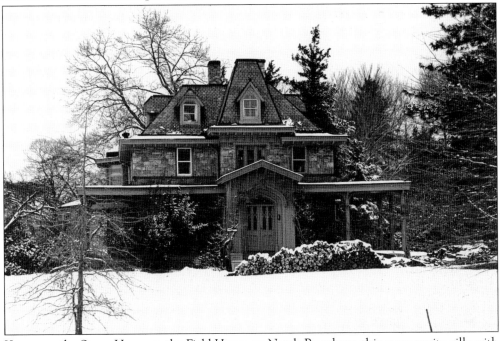

Known as the Stone House or the Field House on North Broadway, this gray granite villa with mansard roof commands a lovely view over the Hudson River from its wide verandas. The house was built in 1867 on Constant farmland and was purchased in the next year by Dudley Field, the son of David Field Jr., the prominent attorney who helped codify state and federal legal systems.

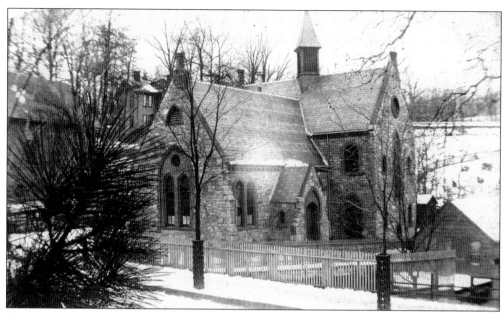

The Fraser Free School was given to Hastings by the Fraser family and was built in 1863 of Rosedale Avenue Quarry bluestone. In design and materials, it resembles the 1869 chapel at the First Reformed Church. The school building served as Hastings's public elementary school until 1904, and in 1912 the Hastings Woman's Club created a village library upstairs. From 1916 to 1929, it was the village hall and village jail. In 1931, it became the home of the Hastings Aerial Truck Company No. 1, later named the Hook and Ladder Company No. 1. In 1955, the Hastings Ambulance Corps was founded in a shed to the back; it moved to a new building across the street in 1979. The photograph below of a class at the Fraser Free School was taken around 1890.

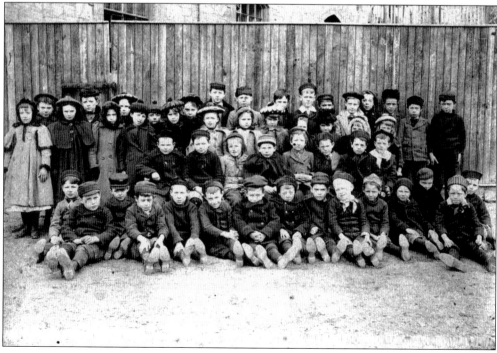

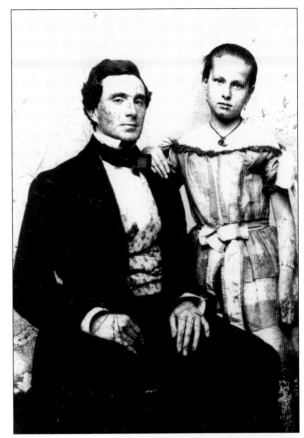

Thomas Fraser and his daughter Jane posed for this formal portrait in the late 1850s. The Fraser home was set on 20 acres of rolling meadows with a northwesterly view of the Hudson River. It was built in 1855 in the American Gothic Revival style, probably from popular pattern books by architects Alexander J. Davis and Andrew J. Downing. Recalling the Fraser's ancestral home in the Scottish Highlands, it was named Lovat. Built with locally quarried marble, it is embellished with elaborate Gothic woodwork details and includes a Lord and Burnham greenhouse. After four generations of Frasers lived in the house, the surrounding property was sold in 1956 for the Park Knolls development, leaving only three quarters of an acre for the elegant house.

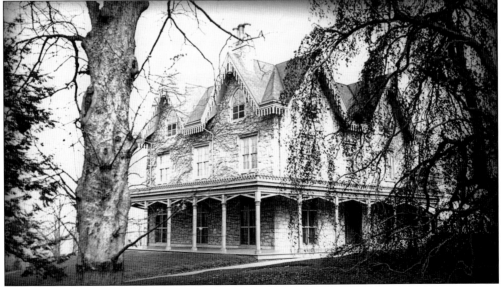

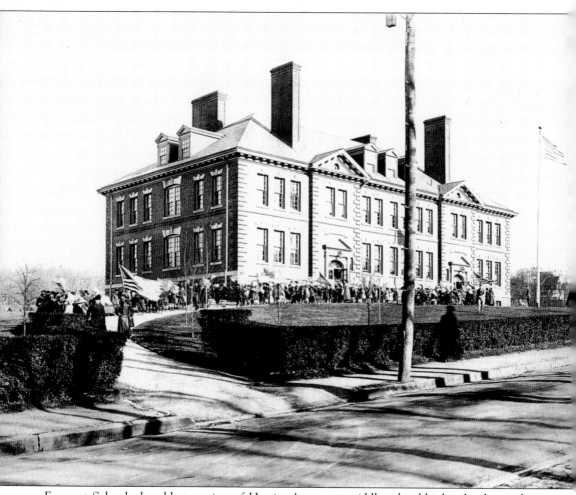

Farragut School, the oldest section of Hastings's present middle school-high school complex, was opened in 1904 for all grades. Many later additions comprise the Farragut School complex today. They include the Washington Wing built in 1911, the High School at Mount Hope and Farragut in 1927, and the School Street addition in 1934. The centerpiece building on Farragut Avenue opened in 1932 and was designed by Richmond Shreve, a Hastings resident and one of the architects of the Empire State Building. The Cochran Gym was added in 1963. The Hillside Elementary building was opened in the Hudson Heights neighborhood in 1962. This photograph shows the building decorated for Armistice Day, November 11, 1918, at the end of World War I.

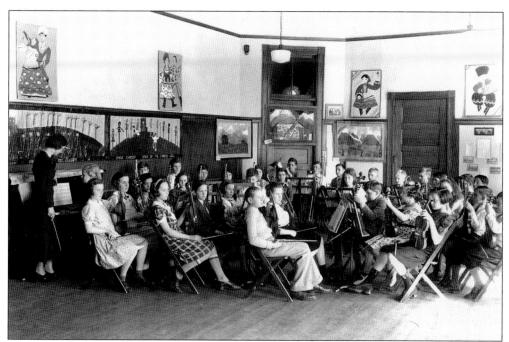

These two photographs illustrate some of the special classes offered in the Hastings schools in the 1930s. Above is a photograph by Hastings photographer Lewis W. Hine. He took many pictures of local scenes, including school activities. This one shows the orchestra class in session in the Farragut School complex, perhaps a middle school group. The image below is a high school home economics class for girls. Doris (Maund) Duddy recalls learning to make "floating island" dessert in the new kitchen. Boys used the kitchen for their popular Chefs' Club, but no girls used the wood shop. The History Club, Dramatic Club, and Journalism Club were among the coeducational offerings.

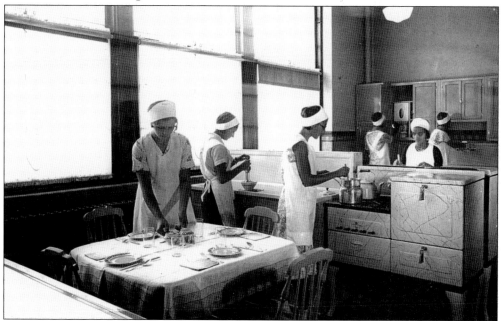

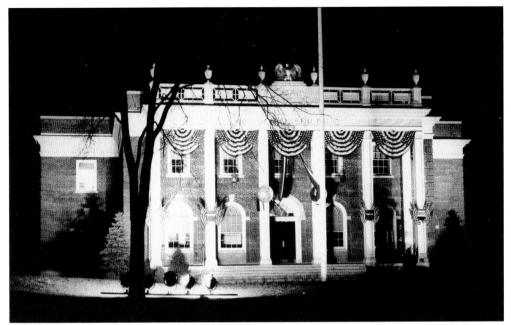

The opening of the municipal building was celebrated on Saturday evening, December 21, 1929, with a testimonial dinner attended by all the citizens involved in the project, including the architect, Richmond H. Shreve. The dinner was catered by Three Fat Cooks, based at the new LaBarranca apartment house. The five-course meal included crème broccoli, broiled half Philadelphia chicken, and ice cream *en forme* and was followed by cigarettes and cigars.

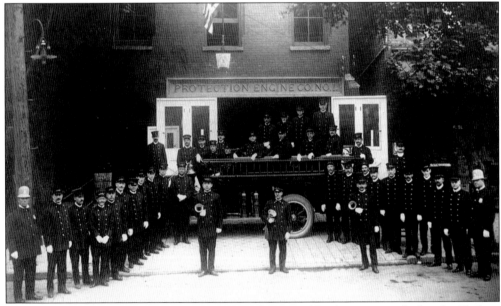

Hastings's first fire company, Protection Engine Company No. 1, was created after the Hudson River Steam Sugar Refinery fire in 1875. It took more than two days to put out the fire; it was clear that better fire protection was needed. Bricks from the refinery were salvaged to build the first firehouse, shown here on Warburton Avenue in 1911, with an early fire truck and all the company volunteers at attention.

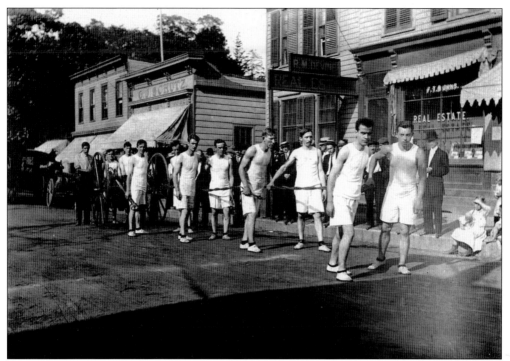

An 1899 fire in the Uniontown neighborhood prompted another fire company, Uniontown Hose Company No. 2. This shows their demonstration of "laying hose" on Warburton Avenue. In 1910, at the Yonkers Empire Company Race Track, a Uniontown team set a world record for pulling a hose cart 200 yards, laying 100 feet of hose, and showing water, all in 44 seconds. They were awarded the Frederick G. Zinsser Trophy.

This cast plaster plaque is by John Donnelly in honor of the first "Smoker" social event by the Riverview Manor Hose Company No. 3 in 1911. It is a caricature of his fellow members of the company. Donnelly is best known for his sculpture at Grand Central Station and the Supreme Court building doors in Washington, D. C. The original Riverview firehouse, also shown in the plaque, was designed by member Richmond Shreve.

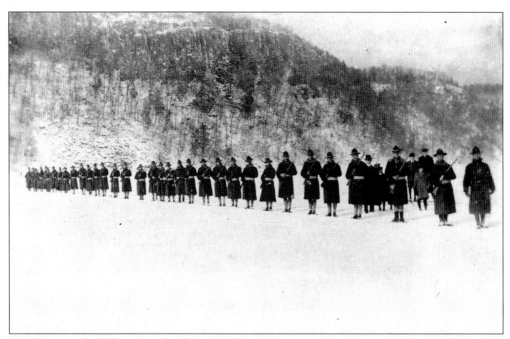

"Drilling—and chilling—on the frozen Hudson River near Hastings-on-Hudson" said Hanford "Doc" Todd in 1917 about his photograph. This Home Guard troop began in 1917 as one of many across the nation and consisted of 133 men ineligible for active service in World War I. Their charge included being alert to bright lights from the Palisades and local hills that might be signals to the enemy. A July 1919 Home Guard call up assisted police in putting down a disturbance at the National Conduit and Cable plant. During wartime, there was great anxiety about the loyalty of foreign-born workers in all the waterfront industries and fear of sabotage. Marie Maher's "War Zone Pass" in the image below is indicative of the security measures taken. After the war the cable company made efforts to improve relations between management and employees by starting ball teams and other entertainments.

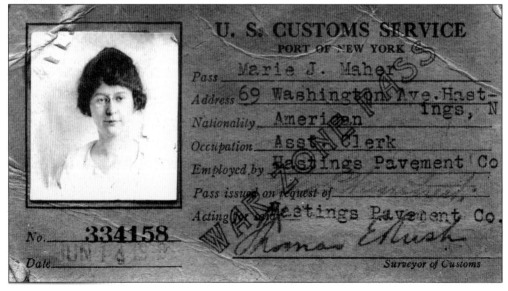

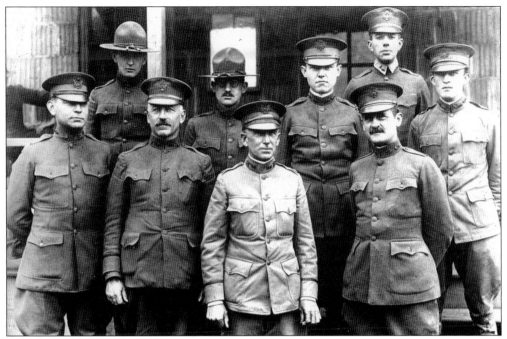

Col. Frederick Zinsser stands in the first row on the right with other members of the Edgewood Arsenal at the Zinsser Chemical Company during World War I. As official members of the U.S. Army, their wartime task was protection of the Hastings federal facility built for the manufacture of mustard gas for the army.

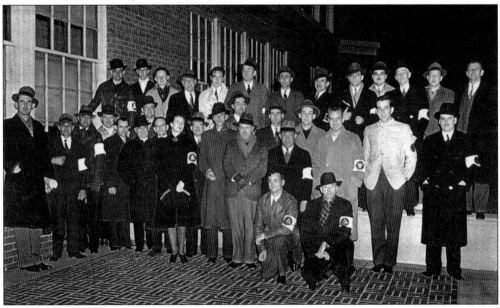

Many Hastings volunteers became village air raid wardens during World War II. Older school children served as junior wardens. The primary task was to be sure that everyone obeyed the blackout regulations when the air raid warning was sounded. The group, including a woman and a priest, gathered for this picture in 1942, appropriately at night. The village was divided into sections, each with its own assigned wardens.

In the 1870s, Dr. Edward Huyler, a patent medicine manufacturer, built his home on the ridge above the river and added a clock tower with four faces (no two of which were said to give the same time). In the 1880s and 1890s, he built two streets, Edmarth Place, named after himself and his wife, Martha, and Ridgedell Avenue. The houses on each street are mirror images of the houses opposite them.

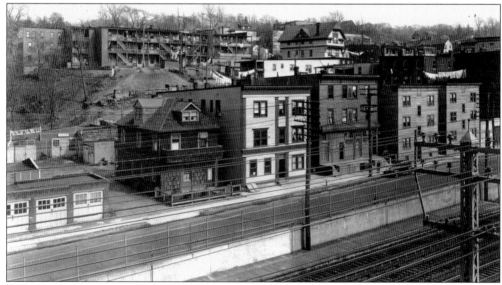

By 1935, Warburton Avenue and the area near the railroad tracks was dense with workers' "cold water flat" apartment houses. This is one of the series of photographs taken by Lewis W. Hine in 1936 to illustrate schools superintendent John L. Hopkins's Ph. D. dissertation, "A Program for the Development of More Adequate Secondary Education in a Suburban Area." Hopkins's study revealed that in 1930, with Hastings's population of 7,097 people, 66.7 percent were foreign-born, mainly from eastern and southern Europe.

54

Four

CABLE CONNECTIONS

"[My father] was part of the yard crew," recalled Emery "Jim" Gavacs in 1988, "and he was breaking up concrete. He drilled into a 15,000 volt line and was electrocuted. The compensation [in 1930] gave my mother $28 a month until she remarried, and each of us $8 a month until we were 18 . . . Anaconda never offered me anything. They didn't come to ask me if I wanted a job . . . We hated them for that. So what happened? I went to work for them. Still and all, it was the only place."

The love-hate relationship Hastings had with its cable companies began after devastating fires nearly wiped out Hastings's waterfront industry in the 1870s, and a significant number of laborers left to find work elsewhere. National Conduit and Cable Company bought up much of the waterfront in 1880 and began making lined pipes. In 1891, they bought the rights to an invention that made possible carrying electrical current on wrapped copper wire, and Hastings's cable industry was born—the industry that would eventually claim most of the waterfront, cut off the general public from access to the Hudson, and in 1975, leave Hastings with decades of legal battles over environmental cleanup, an enormous pile of ugly buildings, industrial waste, and unending controversies over waterfront development. At the same time, it employed generations of proud workers who spoke fondly of the small-town family atmosphere at Anaconda (opened in 1925), enjoyed company outings, and cheered at Anaconda Hastings Arrows baseball games by the thousands. The cable industry also gave Hastings its international character, not only by expanding communication infrastructures throughout the world and fulfilling thousands of government contracts during war and peacetime, but by offering work to immigrants from many countries.

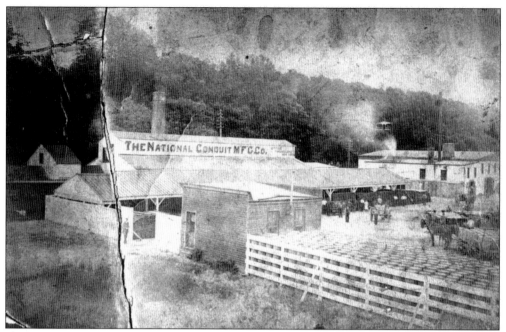

The National Conduit Manufacturing Company, making cement-lined steel pipes, opened in 1880, after fires destroyed most of the other waterfront industries. Their business expanded considerably after the 1891 invention of wrapped copper cable, which could carry electrical current. In 1896, it employed 75 people and, in spite of an extensive cable shop fire in 1899, by 1913, over 3,200 local people worked there. Similarly in 1896, it had $25,000 capital, but by 1918, it had $8,740,000. Working for what was then called the National Conduit and Cable Company (NC&C), Hastings residents produced cable for one of the country's first utilities, Chicago Electric Light Company, as well as for New York's Metropolitan Traction Company and for trams and power lines in Europe. Pictured below is Richard McCartin (left) and NC&C conduits for an 1893 telephone exchange cable system, this one in Brooklyn.

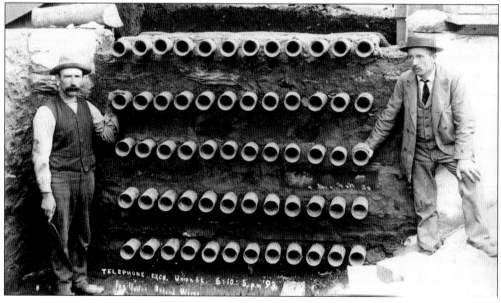

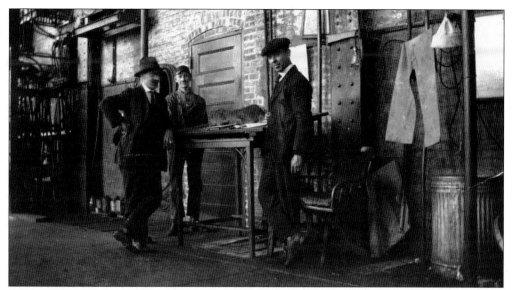

Leo Schlachter (center) and two other employees take a break from their work at NC&C. Beginning in 1912, NC&C increased its payroll to make bullets, shells, and other war materials to ship to Europe. Elizabeth and Helen Schlachter moved from their job at Zinsser Chemical Company because they could earn more than $7.50 a week. Others who worked at NC&C at that time included Rose Duvall, Joe Thornton, and Arthur Schlachter.

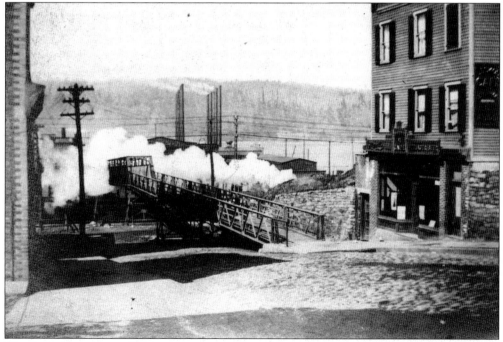

The footbridge at lower Washington Avenue bore the weight of most of the NC&C employees, who made their way through the Hastings Pavement Company "fog" to NC&C buildings each day. For lunch or after work, they might stop in at Lesko's Café (right) or Sikerzycki's Hall (hidden, to left). When Leon Trotsky rose to speak here during the 1916 strike, anti-communist Boleslaus Sikerzycki carried him off the podium.

1912

OUR SHOT IN RIOT IN HASTINGS STRIKE

lice and Special Deputies Fire
Vild Volleys, Felling Innocent
Woman and Workman.

WOUNDED STRIKER MAY DIE

ational Conduit and Cable Co.
Had Deputies Armed—A Hundred
Bullets Answer Stone Throwers

(NY Times June 25, 1912 p.8)

DEPUTY'S GUN KILLS WOMAN AT HASTINGS

Crowd of Strikers' Wives
Attempt to Stop Workers and
Some One Pulls Trigger

1,000 Strikers Agree to Accept
Five Cents More a Day,
Though Demand Was
For 25 Cents.

(NY Times June 30, 1912 p.12)

1916

MOB STONES TRAINS; 2,000 IN STRIKE RIOT

Women Join Attack on
Munition Works and Break
All Windows in Half-Mile
Building

Long Battle for a Bridge

Hastings Strikers Attack Men
Going to Dinner and Drive Them
Back to the Factory

(NY Times April 19 1916 p. 5)

MILITIA QUEL RIOT IN MUNITION STRIKE

Guardsmen, Called by S
Patrol Streets About Big
duit Plant at Hasting

MACHINE GUN STANDS READY

Bloodshed and Disorder Fe
Soldiers Make Quick Tir
After Mobilization Orde

(NY Times April 20, 1916 p

By the second decade of the 20th century, NC&C was a multimillion-dollar company, owned much of the waterfront, owned an upscale housing development at Riverview Manor, published the local newspaper, and employed many town officials. Its unskilled employees earned $1.50 per day and in 1912 struck for an increase of 25¢ per day. By the end of the strike, after the rioting and accidental shootings of seven people resulted in two deaths, the laborers settled for a 5¢ increase. Sympathetic local journalist Hutchins Hapgood lost his privilege to ride the bus from Riverview Manor (also owned by NC&C) to the train station. In 1916, workers on strike for an additional 5¢ an hour smashed every window in the building and for two days refused to allow strikebreakers to leave work by crossing the footbridge. The strikers were put down by the National Guard, 600 strikers were fired, and the rest were forced to accept no increase. Two years later, president Edward Perot and his son, who was vice president, both quit the company.

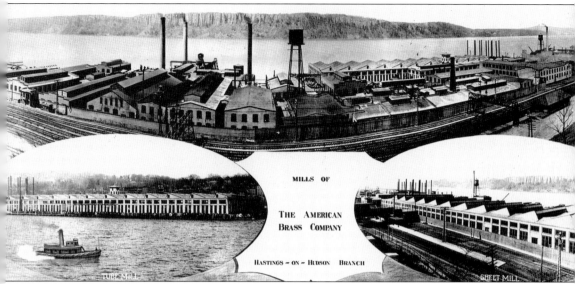

MILLS OF

THE AMERICAN
BRASS COMPANY

HASTINGS - ON - HUDSON BRANCH

TUBE MILL

SHEET MILL

The American Brass Company began investing in the Hastings waterfront late in the second decade of the 20th century. It began in the 1890s as a holding company for a handful of brass companies from Connecticut and took the name American Brass Company in 1899. It specialized in munitions and sheet metal for airplanes during World War I, and when NC&C went bankrupt in 1921, American Brass Company was there to purchase the property. It gave the Hastings waterfront its water tower and distinctive saw-toothed buildings, housing the tube and sheet mills. In 1922, Anaconda Copper and Mining Company purchased the American Brass Company and by 1925 moved it out of Hastings in favor of its Anaconda Wire and Cable Company. Most of the employees, both skilled and unskilled, simply worked for the consecutive owners.

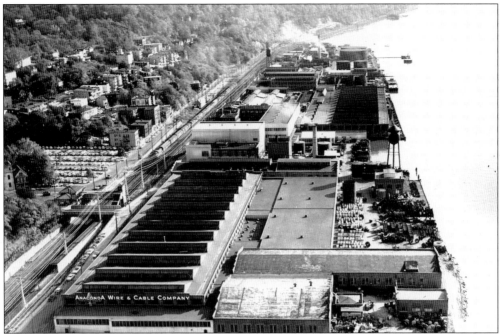

In 1922, Anaconda not only purchased American Brass Company and made plans to move it out of Hastings, it purchased the world's largest copper mines in Chile and Mexico. By 1926, Anaconda Copper and Mining was the fourth largest corporation in the world, and owned much of the backfilled waterfront shown above (looking south). Its subsidiary Anaconda Wire and Cable Company used copper to make telephone wire, electrical wire, mine-sweeping cable, and television cable in Hastings until 1975. The south end of the waterfront was occupied by a succession of chemical, pigment, and oil companies until 2000. The industries created a barrier between townspeople and the river but also provided employment to thousands of Hastings residents. Many of the company's employees lived in the tenement houses shown on Railroad, Washington, and Warburton Avenues.

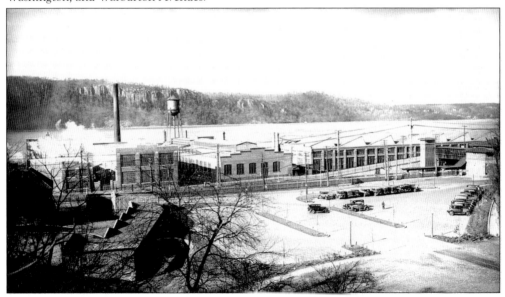

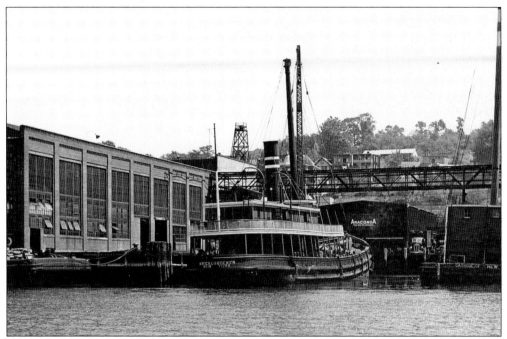

Anaconda's proximity to the Hudson River and the Hudson rail lines provided for easy freight transportation. Shown above in 1939, the *Knickerbocker* was a wooden lighter run by Anaconda between Hastings and Perth Amboy, carrying copper bars, such as those shown below, and reels of finished cable. Both this and her sister ship *Anaconda* crossed the Atlantic during World War II, carrying minesweeping cable and fireproof wire. According to oral accounts, the third Anaconda lighter *Amackassin* provided transportation for company employees' outings to Coney Island. In 1970, the barge *Hastings* (below) accidentally dumped about 400 copper bars valued at $800,000 into the Hudson River at Hastings, which led to days of salvage diving and theorizing about the cause.

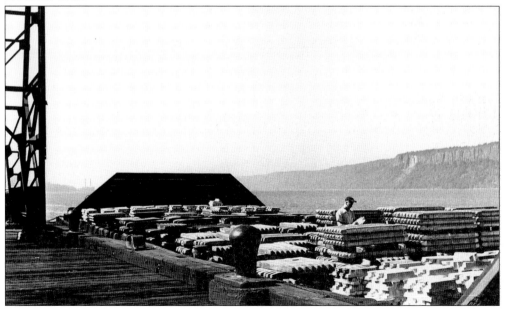

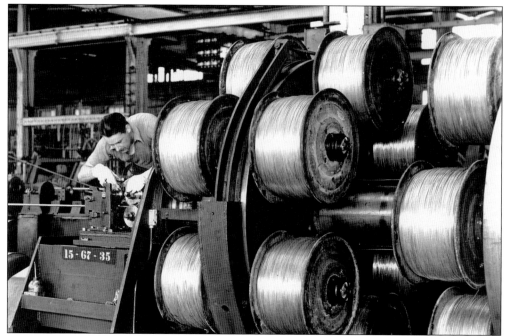

Steve Sutor strands copper cable by gathering smaller strands from the reels on the right and splicing them together to make heavier stock. During World War II, poly-chlorinated biphenyl (PCB) mixtures were used to impregnate cables to make fireproof products for U.S. Navy battleships, including wiring that would not burn if the ship was hit by a torpedo. Post-war construction required miles of wiring and television cable as well.

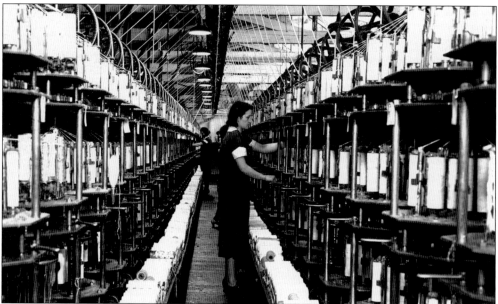

Susan (Milinak) Koslap operated a winding machine like this one for covering and weatherproofing wire. "One time I was putting the wires in and I started up the machine and all of a sudden I caught my sweater in the hooks in the machine—good thing I had scissors because I cut my sweater right off."

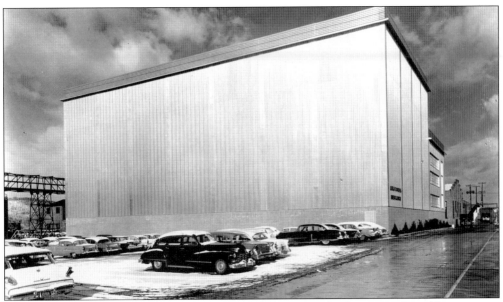

Research and development helped Anaconda keep up with the times. In addition to its weatherproof cable, during World War II it developed buoyant cable that could be suspended between two minesweeping boats four inches below the surface of the water. The cable was energized, and uninsulated electrodes or "pig-tails" would sweep the ocean floor, detonating enemy mines. After the war, Anaconda developed cable capable of carrying television signals.

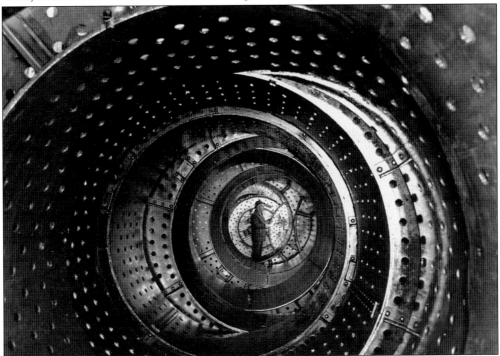

Huge extra high voltage reels were used for impregnating wrapped cable with oil and PCBs. Standing inside the reels is Anaconda's last employee, Jerry Maher. Maher stayed on as a watchman until 1980, five years after Anaconda closed its Hastings plant.

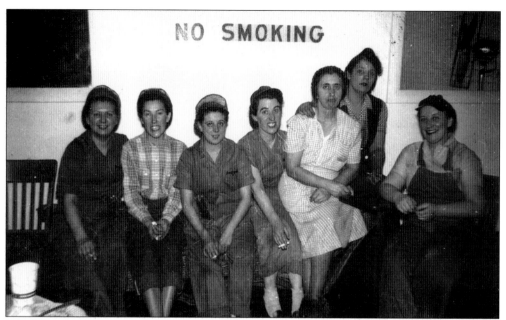

NO SMOKING

Ada Battista recalled, "The people I worked with, we are like sisters. We [spoke] all different languages, but we love each other." Wartime production brought Anaconda workers even closer together. They carried special permits that had to clear security, worked extra hours beyond the usual 50 to 60 hour weeks, and had the sense that they were part of something important. The women pictured here, including Sophie Karschmidt Hoss (second from left) and Louise Capuano (second from right), take a break from exposure to asbestos in the weatherproofing department to have a smoke. All of their hard work was rewarded when each of the Anaconda employees received a U.S. Navy "E" Award in 1944. The ceremony, attended by dignitaries from Washington, D. C., was held at the decorated Hastings factory.

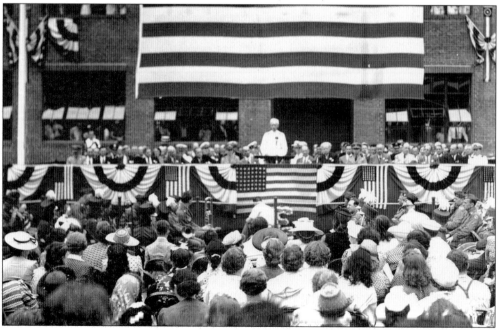

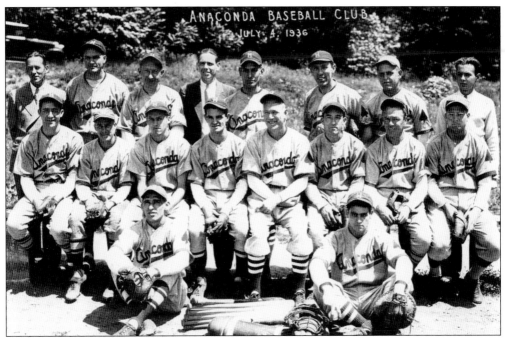

Anaconda teams and clubs helped to build company loyalty. There was a chorus, golf, and bowling, but by far, the most popular was baseball. Anaconda recruited players from high schools, colleges, and semi-professional leagues. Joe O'Mara recalled, "You felt a little funny walking through that gang of men who had families and everything—and you were going in there to get a job because you could play ball." Thousands of people attended games played at Reynolds Field. Players such as John Barris (second row, right) and Thomas Phelan (third row, third from right) became local heroes as the "best pitcher ever" and "the only one who could hit a ball into the road a block beyond the field." Family picnics at Schmidt's Farm on Jackson Avenue and Christmas parties also helped to cement company bonds.

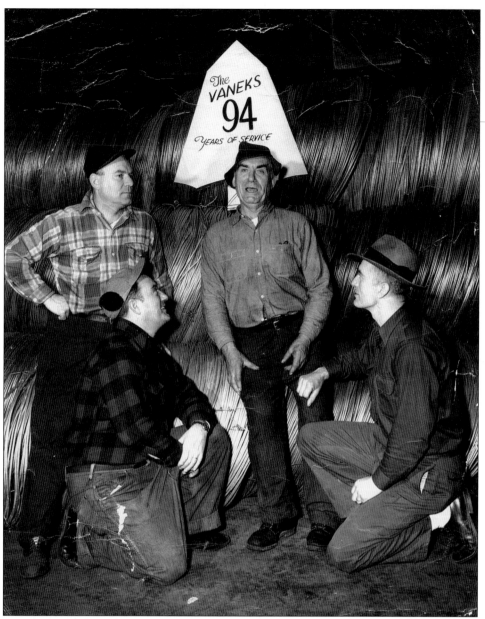

Shown here, in 1954 celebrating Paul "Pop" Vanek Sr.'s 69th birthday, the Vaneks eventually contributed 174 years of service. Seen on the left, John Vanek unloaded copper bars, kept shipping records, and operated an overhead crane in the wire mill. He was a skeptical member of the union, which began in the late 1930s. During the 1967 strike, he blamed them for "getting the place closed down" after someone beat up a foreman on the dock. He fished cod, eel, and big blue crabs from the dock during lunch breaks until oil pollution "covered them with slime." John's brother Andrew (second from left) fed copper bars to his father Paul (third from left), who operated the furnace-loading crane. Paul emigrated from Czechoslovakia and spent 50 years loading copper bars into the hot furnace. The floor of the crane frequently got so hot that it left blisters on his feet. Paul Jr. (right) spliced fine wire until he died of copper poisoning. In all, John was proud of Anaconda and felt that it was a fair place to work.

After World War II, Anaconda established a Suggestion Award, which encouraged employees to create ways to improve the final product or the manufacturing process. The suggestion box (right) was designed to look like the famous saw-toothed buildings on the waterfront. Suggestions that were implemented by the company earned the employee a bonus based on the savings generated; one award was $600. The picture above shows award winners from the reel shop in 1951. From left to right are (first row), Bill Newell, Ed Burke, and John Neely; (second row) Chris Addorisio, Joe Shulik, Tony Marsh, Harold Hadley, and Louis Phigler. Newell recalled earning "a couple of small bonuses." Joe O'Mara, another winner, recalled that he "received five dollars each for eight gadgets that were patented. The agreement that you signed gave ownership of everything you invented to Anaconda."

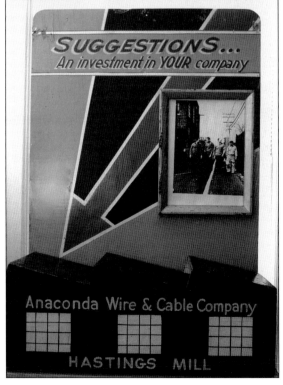

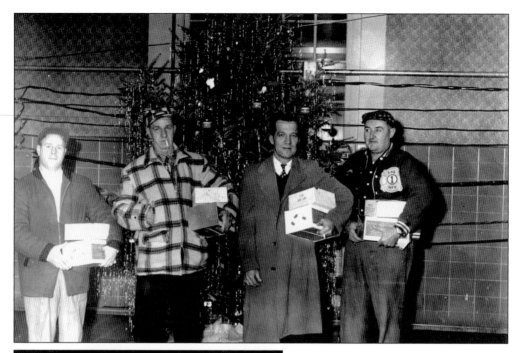

In 1957, Anaconda employees, including, from left to right, John Coyne, Peter Howek, John Duke, and Jim Gavacs, each received a ham and a box of Christmas candy. Gifts such as these, dance parties, and care packages for those in the service, solidified a sense of family within Anaconda. When the AFL-CIO began representing Anaconda workers in the late 1930s, there were mixed feelings. Most workers walked past the office daily, as it stood at the Washington Avenue footbridge, behind where Catherine Emerich (left) and Sophie Ravinsky are sitting. Jim Gavacs gave the union credit for protecting workers and was one of its first members, but said they later "went too far." During the 11-month 1967 strike, Gavacs recalled "we had to support them if we wanted our jobs." Local people gave money to help meet expenses, and mid-western farmers sent food.

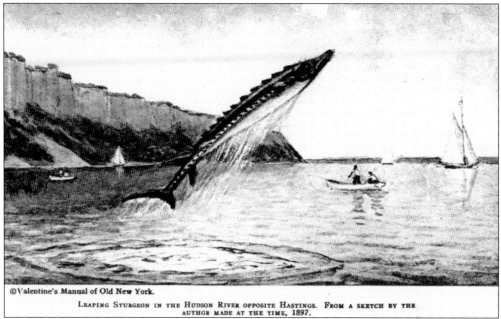

LEAPING STURGEON IN THE HUDSON RIVER OPPOSITE HASTINGS. FROM A SKETCH BY THE AUTHOR MADE AT THE TIME, 1897.

Since before the Dutch arrived, fishing has been a major activity on the Hudson River. Hastings residents fished striped bass, sturgeon (shown above), and shad commercially and for sport. Every spring, the shad return from the Atlantic Ocean to spawn in the fresh water of the Hudson River. Using nets that can be thousands of feet in length, fishermen hauled in millions of shad annually. In the 1960s, however, fishermen observed the poor condition of the fish and the Department of Environmental Conservation restricted and then banned the sale of most fish due to the presence of PCBs released by factories, including Anaconda Wire and Cable. Fishing shacks like the one shown below were soon abandoned and concerned fishermen and environmentalists up and down the river began their struggle to rescue the Hudson River ecosystem.

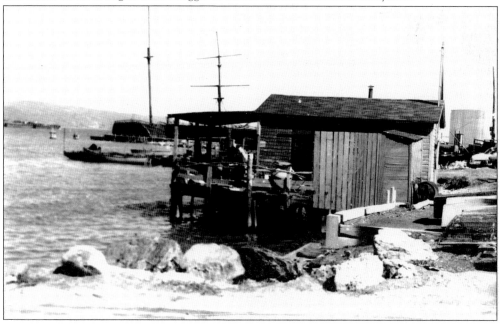

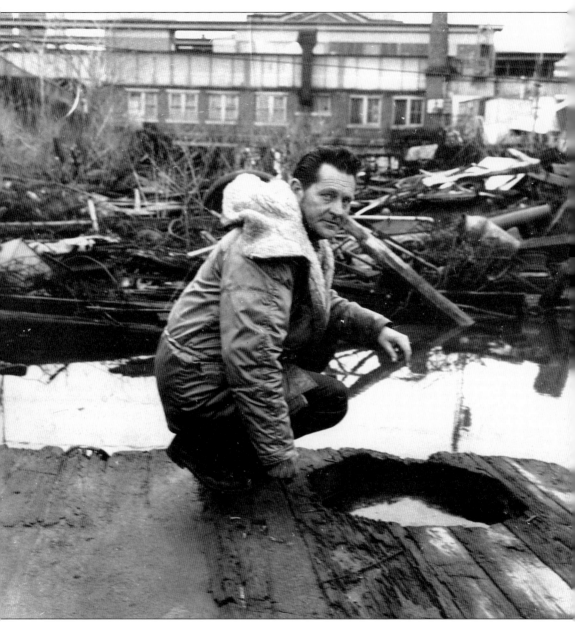

Fred Danback was an Anaconda employee for 18 years and served for a time as union president. He was an avid fisherman and became concerned about the condition of the fish in the early 1960s. He connected the condition of the fish to pollutants discharged by factories on the river, including his own employer. He located the offending pipes and leaking tanks and brought them to the attention of Anaconda management. No remedial action was taken. Danback found a 19th-century regulation that prohibited dumping waste into the river, and after consulting the federal government and learning that the law was still on the books, Danback joined with the Hudson River Fisherman's Association to bring civil action against Anaconda. In order to have legal standing, he had to resign his position with the company. Eventually the court ruled in Danback's favor and fined Anaconda $200,000. At the time, it was the largest penalty ever imposed and marked the beginning of an ongoing battle to clean up the Hudson River.

Five

SOCIAL LIFE

Strong class divisions emerged from the parallel development of Hastings as both a bucolic estate community for well-heeled New Yorkers and an industrial center with a significant population of immigrant laborers reaching for the first steps on the socioeconomic ladder. Julius Chemka tells a story about walking in his Sunday best in about 1935 "up the hill" from his lower Washington Avenue home towards the Tower Ridge section with his father. A police officer told them to "Go back where you belong." For the Chemkas, as well as for other immigrant families in Hastings, moving up the socioeconomic ladder literally meant moving uphill. But socioeconomic progress was possible, facilitated by hard work, spare living, churches and social clubs, and open-minded public schooling. Eventually the Chemkas saved enough money to buy a house on Ridgedell Avenue in Tower Ridge. Julius later became mayor.

There was always "something to do" in Hastings. Eighteenth-century farmers gathered at taverns such as Peter Post's. Laborers relaxed at boxing matches and saloons, played scheduled and spontaneous baseball games, danced on the aqueduct and at Sikerzycki's Hall, or reminisced around a game of cards. Estate owners and their children played tennis and sailed at the Tower Ridge Yacht Club and hosted social club events to raise funds for local improvement. Immigrant children, many of whose tenement homes had no heat or light until the 1940s, studied together at the public library (founded by the Woman's Club), did chores together, swam in the Hudson and Saw Mill Rivers, learned to skate on Three Islands Pond, or played in the ravine. Whether rich or poor, Hastings people shared patriotism, the river, love of theater and dancing, a deep belief in learning, and devotion to sports and used these interests to build a unified community around both formally organized and spontaneous fun.

The outskirts of town provided space for amusements such as those found at Dudley's Grove and Little Coney Island, largely for the benefit of New York City day-trippers seeking relaxation. Dudley's Grove, near the mouth of Rowley's Creek on the Yonkers border, provided a location for drinking, dancing, swimming, rowing, and picnicking from the late 1860s through the early 1880s. The spot was celebrated in Will Morton's song "Up at Dudley's Grove." The refrain went, "She played the concertina as through the woods we'd rove; I was all alone with Kitty McGlynn up at Dudley's Grove." Little Coney Island was a small amusement park created in 1900 by "Goldbutton" Bill Shay in Uniontown, between the Saw Mill River and the Putnam Rail Line. Hundreds of New Yorkers arrived on the "Put" for a day of sliding on the "Zippo," riding the water-powered merry-go-round, and drinking at the saloon. Both parks were at times sites of riotous behavior, resulting in the town's closing of Little Coney Island in 1912.

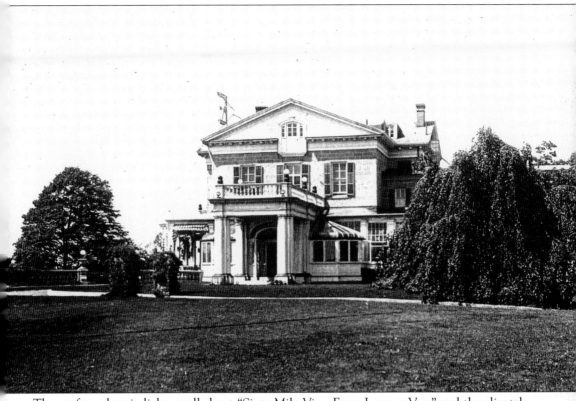

The rooftop electric lights spelled out "Sixty Mile View From Longue Vue," and the clientele shone just as brightly. Beginning in 1910, New York City elites such as the Astors, the DeMilles, and other stars came to the hottest spot in the suburbs. The food, raised on the estate (including the snapping turtles for soup), was by all accounts outstanding. Chauffeurs had their own dining room, where they ate from the main menu at reduced prices. Longue Vue was largely staffed by local residents. Leo Wirz Sr. was head chef until Longue Vue (presently the site of Andrus On Hudson) closed in 1927. Leo Wirz Jr. (busboy) sledded home to Washington Avenue after winter workdays. Other Hastings employees included Andre Faure (chef), who married Emma Skirpura (waitress), Jim Fitzsimon (golf director), and farm supervisors Pat Doyle and David Hallihan, who gave local children rides on the farm horse, Bubbles. Dick Goodwin and Frank McCauley tended bar, while Matty Lavachielly handled valet parking and coat check.

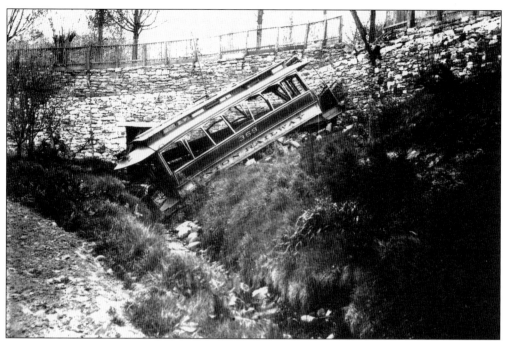

Around 1900, village trustees struck a deal with the Yonkers Railway Company to complete a trolley line north on Warburton Avenue to Main Street, up to the Five Corners, and out Farragut Avenue to Uniontown. The trip required a connection at Main Street and was used to make outings into Yonkers for shopping or to get to school. Others took the trolley to Uniontown, perhaps to enjoy the rides and events at Little Coney Island. There was a tragedy in 1903, when the trolley jumped the track at the Five Corners and plunged into the brook on the Chrystie property. The two-man crew jumped to safety, but a passenger was killed. The regular day crew, Joseph Webb Sr. (on the left) and Tom Hessian, were not on duty, as the accident happened in the evening.

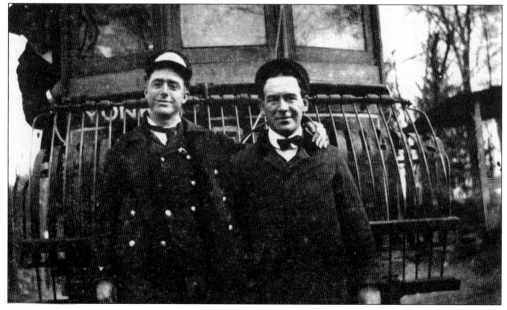

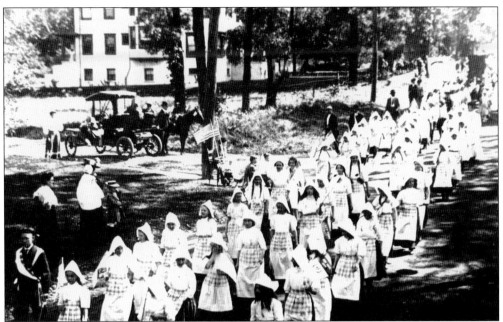

In the fall of 1909, towns up and down the Hudson River celebrated the anniversaries of Henry Hudson's exploration of the river and of Robert Fulton's first steamboat journey. Hastings residents decorated buildings and themselves with flags, children dressed as Dutch settlers and Native Americans to perform plays, musicians composed songs in honor of the day, and the whole town turned out to watch the local Hudson-Fulton Day street parade. The waterfront focus of the day was a 750-vessel naval parade. An early automobile was also featured, here shown in front of 583 Warburton (later Bruning's Ice Cream Parlor), carrying (standing left to right) unidentified, Marion Cook, Stella Cook, and unidentified. Seated at left in the car is Margaret McCartin. Also shown are Palmer Rosenfeld, Florence Hopkins, Annie Holloran, Loretta Hogan, Frank McKernan, Inez O'Keefe, and Florence Lobestein.

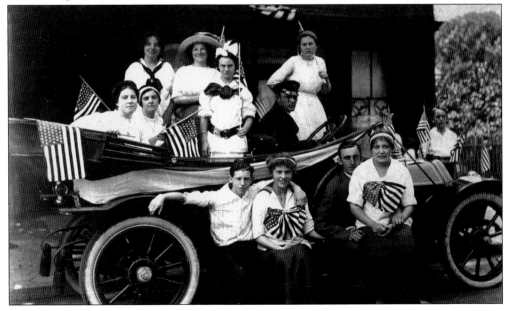

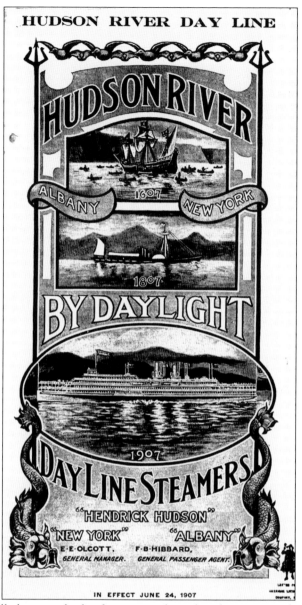

Richly paneled walls hung with the finest art, white-gloved service, and the scenery of the Hudson River itself beckoned wealthy Hastings residents onto steamships operated by the Hudson River Day Line (1863–1948). The new steamboats were known for size, speed, and elegance. A local newspaper reported, "with rare exceptions, the passengers are nice people. The peanut-and-sausage eaters, the beer drinkers . . . expectorators, loud talkers, lifelong enemies of soap and water are never seen here." Hastings residents boarded the "Dayliners" in Yonkers for the nine-hour scenic ride to Albany or to the Catskills or rode somewhat smaller versions to Poughkeepsie, Bear Mountain, Newburgh, or Indian Point Park and back in a day. The day trip was more affordable, and resulted in a somewhat more rowdy crowd. In 1921, Day Line introduced the *DeWitt Clinton*, first of the more utilitarian ships. When Day Line went out of business in 1948, its remaining ships were purchased by other companies. The *Alexander Hamilton* continued in service, the last steam paddlewheel east of the Mississippi, until 1971.

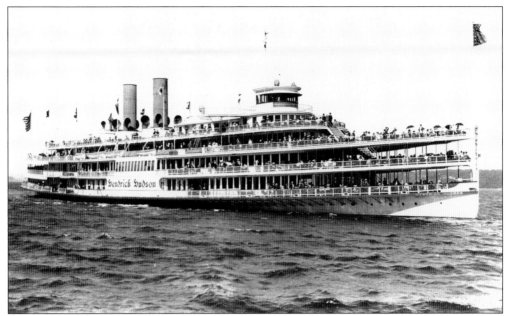

Pride of the Day Line fleet, the million-dollar 400-foot *Hendrick Hudson* led the Hudson-Fulton Day Naval Parade of 750 vessels in 1909. She was the largest and most elegant "Dayliner" yet and could carry 5,500 passengers from Yonkers to Albany in under eight hours. Samuel Ward Stanton's murals depicting the *Half-Moon*, Washington Irving's Sunnyside, the New York State Senate House at Kingston, and the New York State Capitol at Albany drew passengers' attention to historical sites.

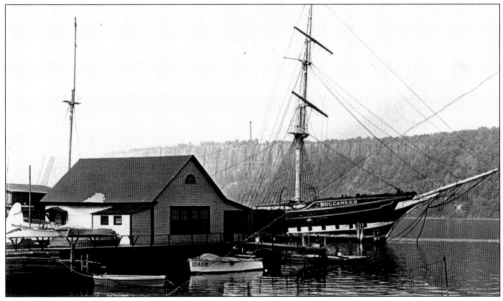

With two of her five barquentine masts removed and replaced by a stage, the *Buccaneer* retired to floating theater service at the Hastings waterfront in 1933. String lights twinkling, her deck seated 1,000 guests for sparkling revue performances. When owner Bobby Sanford went out of business in 1936, the *Buccaneer* was sunk at Robison's pier and became an attractive but illegal swimming and diving platform.

When the New York City members of the Far and Near Tennis Club at Warburton Avenue and Broadway moved to the fashionable new Ardsley Club, the local members founded the Tower Ridge Yacht Club (TRYC) in 1890. They developed a fleet of jib-and-mainsail boats for competitions and social gatherings with other river clubs. The TRYC quickly became the social hub for the wealthy Hastings community, where children could swim and play under the watchful eye of caretaker "Cap" Ed Cook. Teens learned to sail and play seriously competitive tennis, and members organized efforts to assist the healthy growth of the community by sponsoring a host of fund-raisers. Money was raised for village improvements through TRYC-sponsored variety shows and minstrel shows held upstairs at Protection Hall, motion picture shows in the new Farragut Avenue School, lectures such as those by Margaret Sanger, the Farragut Smoker with dignitaries to recall the Admiral, and the glittering Fete Venetian, which teamed up TRYC with the Tonetti Gardens across the Hudson River for music, moonlight boating, and performances.

William Ross was a founder of the TRYC. He owned Riverview Place, including the TRYC tennis courts. Ross, village trustee, Spanish-American War veteran, and office manager of the New York Central Railroad, served as the third commodore of the club (1907–1922) and won several sailing prizes. After the original clubhouse was destroyed by fire, he donated a strip of land and river rights.

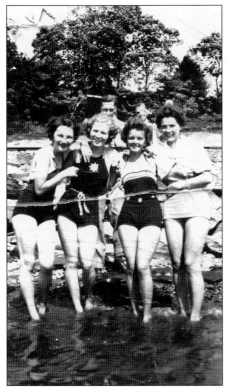

The Hudson River was polluted, but most people found their way to the river anyway for swimming, fishing, and boating. They survived the water. This July 4, 1936, bathing party of, from left to right, Helen Kawalchuk Peterson, Mary Chemka Sirotak, Jennie Dosin McShane, and Helen Kennes has claimed the stretch between the TRYC and Willow Point as their "private beach."

Many immigrant families lived in densely-packed tenements near the waterfront and raised food where they could. Karoline Borys planted fruits and vegetables in her garden behind 405 Warburton Avenue (around 1931), and her sons raised pigeons and rabbits for meat. Fuel for heat came from the Hastings Pavement Company's waste coal or from broken up wooden cable spools (in background). Many people took in boarders to help pay the rent.

"Everybody had this picture on their wall," recalled Frank Waryha. Immigrant families retained a sense of home by seeking the company of extended families or friends through churches. St. Matthew's Lutheran and Roman Catholic Churches were organized by German and Irish-Americans. Later, Eastern Europeans joined St. Stanislaus Kostka Roman Catholic Church, and Rev. Vincent Daszkiewicz (1926–1963, right, with the bishop) became an important influence in family and community life.

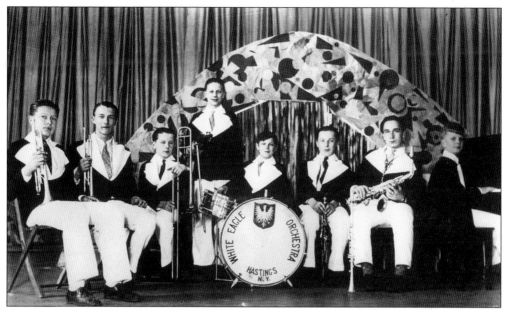

Some immigrant communities preserved their home cultures through ethnic or religious education. St. Matthew's School (opened 1898) provided Roman Catholic schooling for kindergarten through eighth grade. August Plocharski's Polish school offered weekend classes and activities, including the White Eagle Orchestra, shown here performing at the high school's Rainbow Review. Seen are, from left to right, two unidentified boys, Frank Sachar, Frank Plocharski, Vincent Sachar, Joe Sachar, Gabby ?, and Walter Plocharski.

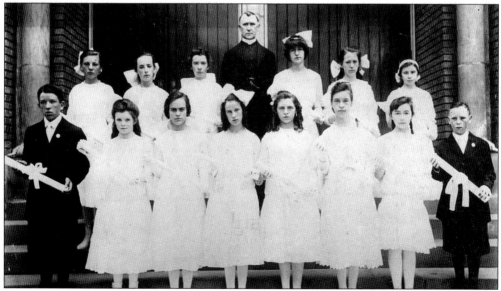

Fr. Thomas O'Keefe was the central figure at St. Matthew's Roman Catholic Church from 1907 to 1940. He said mass, performed marriages and baptisms, and supervised the school and its functions. The class of 1916 shown here includes, from left to right, (first row) William Gorman, two unidentified, Nancy Flynn, unidentified, ? Walsh, Catherine Duddy, James Crotty; (second row) Catherine Hogan, Elizabeth Conroy, unidentified, Father O'Keefe, Muriel Hogan, ? Murphy, and ? Cropsey.

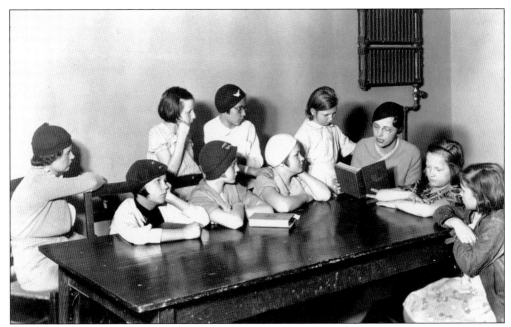

A child-child murder in the "foreign section" of town in 1933 drew the authorities' attention to squalid living conditions for immigrant children. A new recreation committee formed the Boys and Girls Clubs in 1934, which met regularly at the Farragut Avenue School. The clubs provided a warm, clean place for play and also provided activities geared toward assimilation. In the photograph above, Russian and Polish girls listen to a story read by librarian Martha Wright Baird. Immigrant children typically played on Washington and Warburton Avenues, Railroad Avenue (now Southside), and Dock Street (now Spring Street), in the ravine, and on the aqueduct.

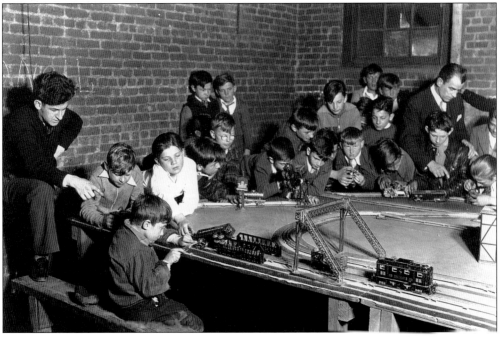

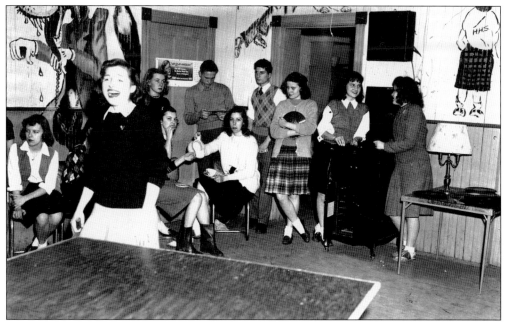

"Our ping-pong table and Victrola were in constant use!" From left to right are Barbara Gould, Sally Ford, Helen Broach, Flossie Townsend, Jack Ross, Phyl Burke, Peter DiChiara, Joan Garey, Gloria Sekorsky, and Nancy Strong, shown in the Hastings Youth Center they renovated in 1947 with Anna DeSanto's support. By 1950, "Mrs. De" and the teens had convinced the town to build the Hastings Youth Center (now Hastings Community Center) on Main Street.

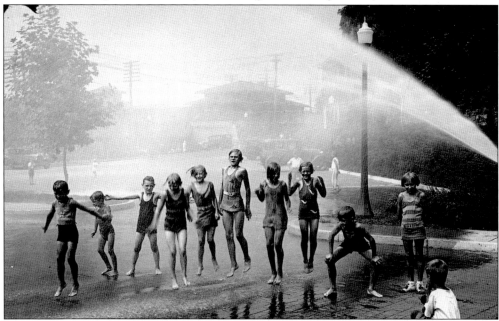

The ravine (now Zinsser Plaza) was a logical place for working-class children to play as it was mainly free of traffic, but it had been used as an industrial dump for decades. Piles of twisted metal, garbage, waste coal, and ash greeted children every day. A massive clean-up project begun in 1931 turned it into a park, with swings, seesaws, and space for baseball and other games.

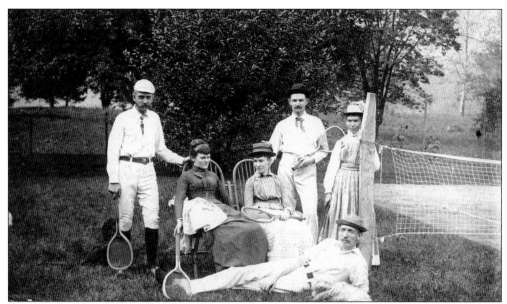

Tennis was a favorite sport among those families who could afford private courts or club memberships. The Hopkes (pictured) and other families enjoyed lawn tennis, and from 1882 until 1890, the Far and Near Tennis Club drew members from New York City and Westchester. In 1910, the TRYC opened two clay courts and became the center of tennis activity until they disbanded their competitive teams in 1939.

Prize fighting was a popular and dangerous activity that drew thousands of spectators from New York City. Traveling by barge, they enjoyed matches that lasted hours and resulted in serious injuries. In 1841, Christopher Lilly killed Thomas McCoy in a contest that lasted 119 rounds. Forty years later, John L. Sullivan, future world heavyweight champion, defeated John Flood in front of 500 fans crowded onto a barge on the waterfront. (Andre, Sam and Nat Fleischer. *An Illustrated History of Boxing.* Revised Ed. by Nigel Collins. New York: Carol Publishing Group, 1997.)

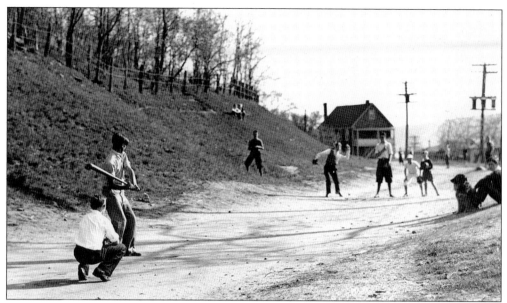

Baseball was played all over Hastings by boys and men of all ages. Some games were informal, on makeshift fields in the ravine or on the aqueduct, as seen in the above Lewis Hine photograph. There were also organized games played on Reynolds Field and sponsored by the Rotary Club. In 1927, the Boys Summer League opening was highlighted by a visit from New York Yankee legend Babe Ruth. The event drew hundreds of spectators from all walks of life including local politicians, school administrators, policemen, soldiers, and local businessmen. In the photograph below, Babe Ruth is on the left, about five rows back. A group at center right includes William Steinschneider, J(?) Murphy, David McQuade, Jack Maher, and Lake Owens. Walter Scully is in the straw hat near the flag. Youngsters in the front include Jerry Diaz and Al Ansel.

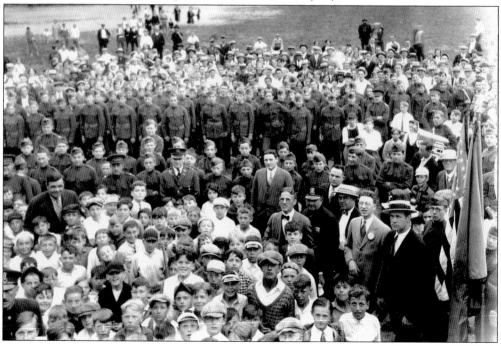

Village residents looking for an ice cream soda or sundae often stopped at Bruning's Ice Cream Parlor on Warburton Avenue. August "Gus" Bruning and his wife served homemade and Breyer's ice cream and other tasty treats, and his establishment was particularly popular before and after a movie. For those who preferred a cold drink and a sandwich, the fountain at Jacobson's Drugstore at 544 Warburton Avenue was another popular option.

The waterfront area was home to a variety of saloons that catered to working-class residents. Many factory workers stopped for a drink at the end of a long shift. Dunn's Bar and Grill on Spring Street (also known as Wolf's Bar and Grill) was run by Nora "Ma" Dunn, second from left. Ansel's, Susan's, Leslie's, the Green Tavern, and Poli's also served the ethnic neighborhoods in town.

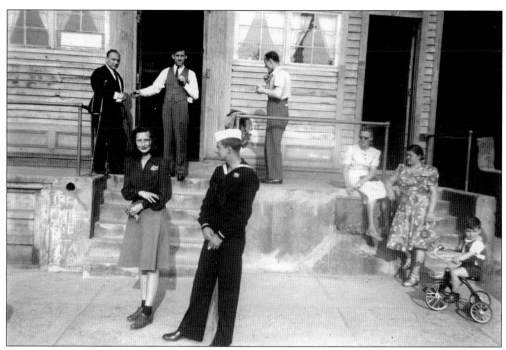

In 1939, a group of mostly Eastern European friends from the area south of the Warburton Bridge created the Southside Social and Athletic Club (SSAC). In 1940, they opened at 113 Railroad Avenue (presently Southside Avenue). Southside became a social hub of young working-class families. Social activities included daily gatherings for pool, ping-pong, cards, music and television, holiday parties, dances, Italian and Polish nights, and clambakes. From 1940 to 1946, SSAC took on all challengers in the tri-state area in basketball and won all 54 games. Proceeds from basketball and softball games went to children's charities. Of the 114 SSAC men who served during World War II, four of them lost their lives. The club kept members such as Andrew "Dod" Burochonok informed of the whereabouts of their clubmates serving overseas and of local events through Hanford "Harry" Todd Jr.'s *News At Home*.

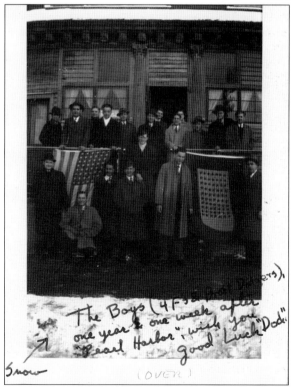

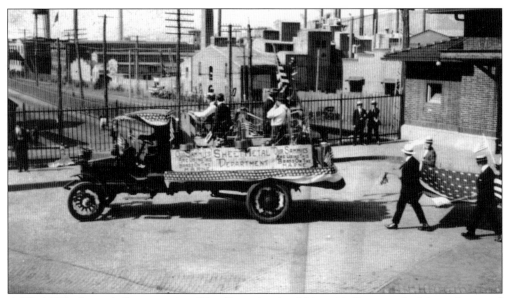

A World War I parade float asserting "Our Sammies Are Using this Brass on the Marne," entered by the sheet metal department of NC&C, in a street parade celebrates local contributions to global events. Waterfront industry, nursing corps, the Home Guard, and other group events brought the community together. The Zinsser family opened their garden to the public, creating Hastings's first community garden and park.

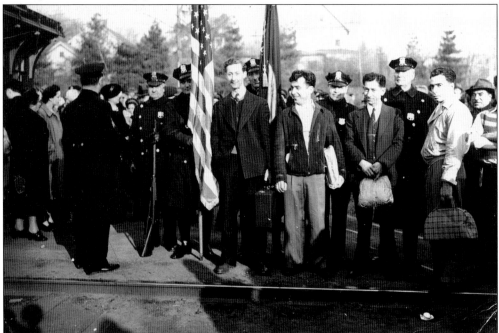

Over 1,000 Hastings men and women served in the armed forces during World War II. Many of the recruits received a hometown farewell, complete with a police honor guard. Bertran Wendell (between flags) and John Melella, second on his left, are joined by Sgt. George Murray (left, back to the camera) and officer Dave McQuade (holding rifle). Though Wendell and Melella came home, 31 village residents did not survive the war.

World War II brought the people of Hastings together in many ways. Victory gardens, salvage drives, blackouts, care packages, and service flags in windows were common. Some families, like the Bradys, the Stefankos, and the Slavins, sent several sons to fight. "Wally" Martin was presumed dead until his family received a letter from him. Mailman Jack Duddy closed the post office and hitched a ride to Martin's home with the news.

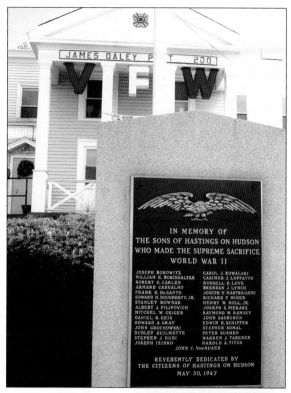

Though the war was over, the spirit of cooperation and giving did not end in Hastings; high school students continued to think of their counterparts in Europe. In 1949, students packed Hershey bars to send off to children in their sister city, Hastings, England. From left to right are Ann Brosnan, Tommy Fox, Channing Murdock, Judith Landsberg, Polly Strong Faria, Frank Brosnan, Ray Miller, Jerry Landzert, Sharman Douglas, and Fred Oman.

With the war behind them, Hastings residents prepared for a promising new chapter in their lives. During the winters, the mound of snow dumped off the Warburton Avenue Bridge into the ravine created great sliding on "Mount Haines" (named after Mel Haines, the director of public works), this time for Sue Lindemann Starapoli. Phyllis Schumm, Jimmy McCue, Bill Costello, and Steve Ravinsky cheer her on down the steep slope. These teenagers are sliding on May 1, but the snow piled up after the blizzard of 1948 did not melt completely until July

Six

NOTABLE NEIGHBORS

In addition to the diversity and energy brought by immigrants from around the world seeking work in local industries, Hastings was a magnet for the social elite. Washington Irving set the tone, creating the picturesque Sunnyside in 1835 with the help of his Hastings friends George Harvey (who designed and built it with him) and Joseph Anthony Constant (who gave him seeds for his extensive gardens). The romantic setting, with pastoral scenes of cows grazing near sweet-smelling orchards with the Hudson River and the Palisades in the background, created an unbeatable aesthetic draw for the highly cultured New York City elite. From merchant tycoons to actors and writers, Hastings offered relaxation and inspiration. Creative energy of all sorts was encouraged, and by the end of the 19th century, Hastings could boast of well-known inventors, scientists, businessmen, actresses, artists, and architects. By the beginning of the 21st century, over one-tenth of Hastings's population was published authors.

Many recall that Hastings felt like "the kind of place where you did not need to dress up to go out." Its unassuming character and social openness made room for eccentrics, too. One legendary character, Johann Stolting, moved to Hastings in 1837 and in some ways, reminded people of Irving's Rip Van Winkle. Bearded Stolting walked around town shoeless and reportedly slept in a coffin. Billie Burke and Flo Ziegfeld once had a pet elephant. Janet Murphy affectionately recalled pen-and-ink artist Winifred Murphy, who walked the town constantly in her corduroys and oxford shoes at a time when most women wore dresses, sketching people's homes and offering to sell the drawings to the owners. Children accepted seeing famous people as a way of life. Notables such as the artists Menconi and Carl Brandt, actors Walker Whiteside, Frank Morgan, Ricki Lake, and Jonathan Winters, as well as Olympic athletes, leading environmentalists such as J. Otis Swift, and Nobel Prize winners shopped and socialized downtown. All sorts of people were attracted to Hastings, and Hastings welcomed them, building a creative and energetic atmosphere and a village with both "characters" and "character."

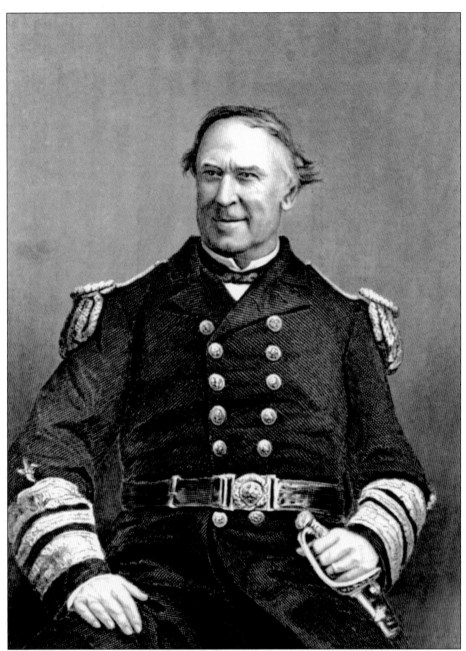

David Glasgow Farragut arrived in Hastings in 1861 with his wife, Virginia, and son Loyall. Though born in the South, Farragut moved north after Southern secession in order to maintain his longtime service in the U.S. Navy. Assigned to a desk job at the Brooklyn Navy Yard, he resided at 60 Main Street. Later given command of the Western Gulf Blockading Squadron that covered ports from the Rio Grande to Florida, the family moved to 128 Washington Avenue, shown on the opposite page. With orders to capture New Orleans, he sailed his flagship Hartford past two active Confederate forts accomplishing his goal and splitting the Confederacy. After a visit home, he fought for control of Mobile Bay. Tying himself to the rigging to better view the course of the battle, Farragut is credited with shouting, "Damn the torpedoes. Full speed ahead."

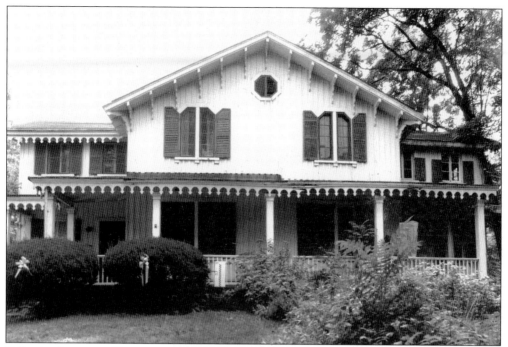

Following his return, Farragut gave $600 of his prize money toward the building of Grace Episcopal Church. Living on Draper family property enabled him to often visit the observatory nearby. In 1865, the Farraguts were lured to New York City by a gift of over $50,000 for a Manhattan residence. He was named the first full admiral of the U.S. Navy in 1866. He died at age 69 in 1870.

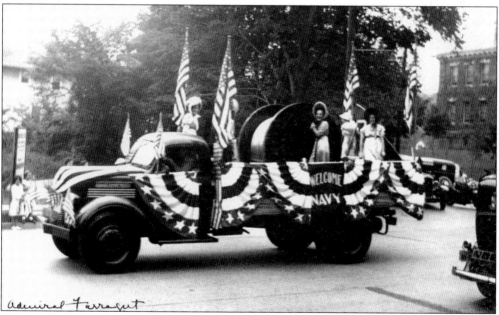

Hastings has honored the memory of Farragut's sojourn by naming one of its schools, an avenue, a short parkway, and an American Legion Post after him. The Admiral Farragut Celebration on July 4, 1937, included a truck decorated with bunting, an Anaconda reel, and five costumed ladies.

In 1847, John William Draper bought a house and 20 acres in Hastings for his family. Already established as one of the founders of the University of the City of New York Medical School (now New York University) and a pioneering photographer, he had taken one of the earliest daguerreotypes of the human face and the first of the moon. He later photographed the solar system as well as slides under a microscope. As a historian, Draper authored a three-volume history of the Civil War.

Henry, John William's second son, was a surgeon at Fort McHenry in Baltimore during the Civil War. Before reporting for active duty, he already had constructed a telescope and built his first observatory near his family's house. After returning to Hastings in 1863, he took 1,500 photographs of the night skies and authored a monograph *On the Construction of a Silvered Glass Telescope*, which was published by the Smithsonian Institute.

Dorothy Catherine Draper, John William's elder sister, appears in one of the earliest photographs of a human face. She lived in the Draper house, assisting his invalid wife and their five children. The exposure time for this daguerreotype was 65 minutes, so John William invented a brace to hold the head still. In pioneering portrait photography, he was proud to have created an occupation that enabled respectable women to earn a living.

Henry Draper made the negative for this photograph, taken through a telescope, in 1863. His images of the moon were the clearest of any yet obtained. George Bond, then director of the Harvard Observatory, declared them magnificent. In 1983, the Hastings Historical Society gave the original negative to the Smithsonian.

Antonia Maury, granddaughter of John William Draper, worked at cataloging stars at the Harvard University Observatory. After retiring in 1935, she moved to Hastings, where she was appointed curator of the Draper Museum in the Observatory Cottage. She is shown using the Alvin Clark six-inch telescope that she purchased for use in Draper Park. She encouraged citizens to visit the park for astronomy lectures and nature walks.

Henry Draper's observatory, built in the 1860s and pictured here in 1880, had two domes. The "new" dome (center) revolved. In 1912, Henry's younger sister, Antonia, remodeled the building into a residence for herself. She bequeathed it to the American Scenic and Historic Preservation Society, and in 1990 trusteeship of the property passed to the Village of Hastings. The Hastings Historical Society began leasing the building in 1994.

The Hastings Historical Society owns one of Daniel Draper's Self-Recording Thermometers. The thermometer produced a continuous weekly record of the temperature on a circular paper chart. The movement of the pen was controlled by bimetallic strips that expanded and contracted in response to the temperature nearby.

Size, 14″ x 20″

Price, $30.

Daniel, John William's third son, had a five-year apprenticeship at the Novelty Ironworks where he worked on early ironclads. His scientific knowledge was recognized in 1868 when he became the first meteorologist for the city of New York. During his 42 years of service, he recorded temperature, precipitation, atmospheric pressure, and wind direction hourly using self-recording instruments that he invented. Daniel's study of storms foreshadowed later weather forecasts.

Lewis W. Hine (1874–1940) is considered by many to be the father of contemporary photojournalism. He began by using photographs to teach his botany students and then moved on to recording the human strength and dignity of immigrants at Ellis Island. Caught up in the social welfare and reform movements, he travelled the east coast to photograph, for magazines, the trials of children in the workplace and others oppressed in the industrial milieu. Because of his diplomatic, humane approach, he was able to bring significant sociological truths, often with his own captions to the public, always revealing his subjects as worthy of understanding and compassion. Later at the request of Richmond Shreve, a Hastings neighbor and architect of the Empire State Building, Hine lashed himself to beams and took outstanding aerial photographs of workers high above New York City. (© Berenice Abbott/Commerce Graphics, NYC.)

Margaret Sanger's mother died at age 49 after 11 births and seven miscarriages. Her mother's experience led Sanger to the new field of birth control. She studied nursing at White Plains Hospital. While living in Hastings (1907–1912), she gave one of her first public lectures at the Tower Ridge Yacht Club. She published *Woman Rebel* magazine and several books. (Margaret Sanger Papers, Sophia Smith Collection, Smith College.)

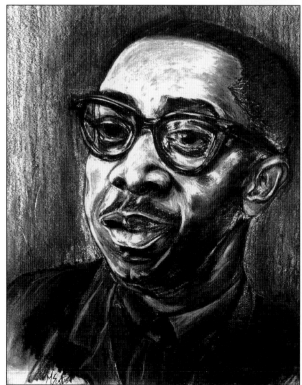

Kenneth Clark and Mamie Phipps Clark were the first African Americans to receive psychology doctorates from Columbia University. Their studies on self-perception in African-American children influenced the Supreme Court justices in the landmark decision that ruled public school segregation unconstitutional. With their children, the Clarks moved to Hastings in 1950 and lived there until their deaths. This charcoal drawing is by local artist Madge Scott, a family friend.

Hastings has long attracted talented writers and artists who have been generous in their support of the Hastings Public Library. In April 2002, the Friends of the Library and the Hastings Library Board of Trustees hosted a celebration of local authors and illustrators to raise funds for the first major renovation of the Hastings Public Library since its 1966 construction. Months before the event, the authors and illustrators were invited to a photograph shoot by local photographer John Maggiotto. Pictured above are 51. As a result of this photograph, many more

authors contacted the library staff and friends to express their interest in being part of the "Book People on Hudson" fund-raiser. All donated their books to sell and autograph, their time to be part of five panel discussions, and items and services for a silent auction. A monetary success, the event also brought together these talented neighbors who make up more than a tenth of Hastings's population.

Ed Young has lived in Hastings since 1975. He is the illustrator of more than 75 books including the 1990 Caldecott Medal–winning book *Lon Po Po* and Caldecott honor books *Seven Blind Mice* and *The Emperor and the Kite*. His work is a unique blend of Chinese and Western cultures. He is shown with his daughters Antonia and Ananda at the opening of an exhibit featuring drawings of his adopted village.

Charlotte Zolotow has had a long career as a children's author and editor. She has written more than 70 books including *William's Doll*, *Grandpa Lew*, and *I Know an Old Lady*. While her books depict a safe world, her themes, which include death and being different, were groundbreaking. In 1981, Harper made Zolotow head of her own imprint, an independent publishing unit. She has lived in Hastings since 1955.

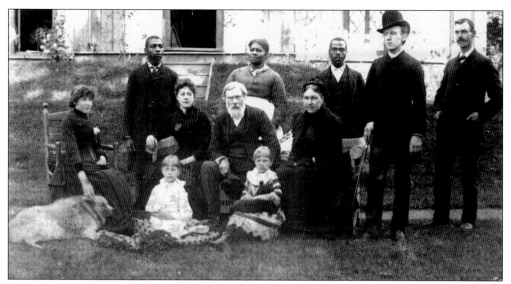

Jasper Cropsey (1823–1900) was a well-known member of the Hudson River School of painting, especially famous for his vivid autumnal landscapes. He was a founder of the American Water Color Society. He moved his family, above, to Hastings in 1885. Having apprenticed in an architect's office, he was also noted for his optimism regarding American design and his contributions to decoration and furniture.

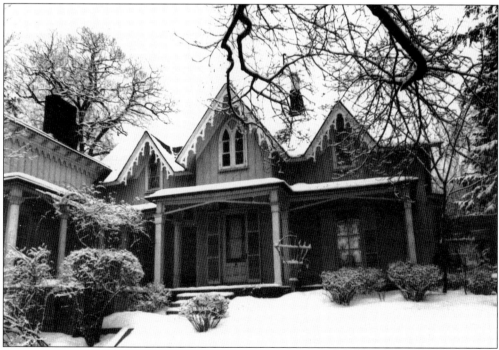

Cropsey purchased this Gothic Revival frame cottage overlooking the Hudson River on three and a half acres and named it Ever Rest. He made it a showcase of Victorian decoration and added a studio for himself including an inglenook by the fireplace. The property was occupied by the family until 1977 and is now on the National Register of Historic Places, and lovingly maintained by his granddaughter's Newington-Cropsey Foundation.

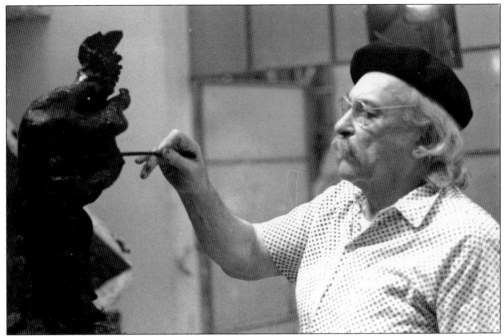

Jacques Lipchitz, a world-famous cubist sculptor, was born in Lithuania and trained in Paris, which he fled in 1940. He moved to Hastings in 1947, where he maintained both a home and a studio for 26 years. When the Creative Arts Council asked if he would sell a sculpture to the village, he offered to donate a work instead. Casting and mounting were covered by community fund-raising.

The Lipchitz 11-foot bronze statue, *Between Heaven and Earth*, is a column of intertwined figures supporting a shrouded figure enveloped in a sweeping veil and capped by a dove. Dedicated on May 7, 1967, it stands outside the Hastings Public Library and the municipal building. The library (donated by Helen Benedict, a member of the Andrus family) is built on a hill overlooking the Hudson River.

Leonard Rose, a world famous cellist, cello teacher, and a 20-year Hastings resident, appeared on the stage of the Hastings High School Auditorium on May 5, 1967, as part of the celebration of the installation of the Lipchitz sculpture. He played Faure's *Elegie* and Chopin's *Introduction and Polonaise Brilliante*. Later, he performed another concert to support the Hastings Drug Council.

George Jellinek was born in Hungary, escaping in 1939 before the Nazi takeover. After serving in the U.S. Army, he joined WQXR and became music director. He was, for years, the host of the "Vocal Scene." With its erudite broadcaster's remarkable, encyclopedic grasp of opera, the program was carried on 75 radio stations nationwide. Locally, Jellinek donated a very successful yearly program to the elementary students at Hillside School.

105

Hastings, dubbed "Smarty Town" by the *New York Daily News*, has been home to six Nobel Prize winners. At left, Max Theiler, the 1951 winner in physiology for his pioneering work on yellow fever, boards a plane to Stockholm with his wife and daughter Elizabeth. He was followed in 1968 by Jack Steinberger and in 1975 by James Rainwater, both of whom won prizes in physics.

In 2006, Edmund Phelps was the third Hastings recipient of the Nobel Prize in economics, following William Vickery in 1996 and Robert Merton in 1997. Phelps's specialty was a sophisticated explanation of how wages, unemployment, and inflation interact. He is shown giving his acceptance speech in Stockholm. (Courtesy of Diane Bondareff.)

Elsie McLave Muller (1895–1967) was a world-class speed skater who practiced on the Hudson River and nearby reservoirs. At night, after her secretarial job was over, she skated just for the fun and thrill of it. Having won metropolitan, national, and international competitions, she appeared on the 1932 Women's Olympic Exhibition Team at Lake Placid before women could compete for medals. Later she became a champion golfer.

In 1948, Steve Lysak (left) competed in the London Summer Olympic Games using a canoe that he had built himself. Long before, while living at the Graham School, Lysak had developed a love of the Hudson River and canoeing. After college and service in World War II, he returned to this area and practiced with his friend Steve Macknowski (right). Together they took the gold medal in the 10,000-meter race.

George Ober (1849–1912) began his theatrical career as a boy performing on stage in Baltimore with John Wilkes and Edwin Booth, among others. Later he moved to New York City and enjoyed success in many supporting roles. In time, he pioneered open-air productions in Hastings and at resorts in the Catskills and became well known for his portrayal of Rip Van Winkle. Before his retirement, he appeared in several early movies.

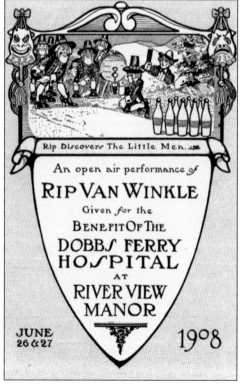

The proximity of Hastings to New York City has lured many recognized actors to establish homes here. Stars of the Broadway stage, as well as movies and television, such as May Yohe (once owner of the Hope diamond), Stephen Collins, Henry Kulky, Ricki Lake, David Manners, and Walker Whiteside, among others, have lived here.

Brothers Frank and Ralph Morgan were successful stage and screen actors. Frank was a character actor during Hollywood's Golden Age, best known for his portrayal of the title character in 1939's *The Wizard of Oz*. He appeared in over 100 films during his 36-year career, was nominated for two Academy Awards, and has a star on the Hollywood Walk of Fame.

Broadway beauty Billie Burke's acting career began in 1907. Her first films were shot in New York City, and between films she would return to the stage. In 1914, she married producer Florenz Ziegfeld. She retired from films in 1921. After their fortune was lost in the Wall Street Crash of 1929, she returned to films in 1932, and is fondly remembered for her role as Glinda in *The Wizard of Oz*.

Before marrying, Billie Burke bought an estate in Hastings in 1912 and lived there with her mother, Blanche, until her marriage. In 1916, after the birth of their daughter Patricia, the Ziegfeld family returned to Hastings and Burkeley Crest. Here they lived a lavish Broadway version of suburban life. The family pets included several dogs and a menagerie of bears, monkeys, lion cubs, an elephant (named Ziggy), a buffalo, ponies, and parrots. Amenities included tennis courts, an exotic swimming pool, and, for Patricia, a large playhouse that was a replica of George Washington's Mount Vernon, with electricity and running water. The family lived at Burkeley Crest until the early 1930s.

Seven

SUBURBAN HASTINGS

Hastings is about 15 miles north of Manhattan—about half an hour by commuter train. The north-south axes of the topography, the rivers, the Old Croton Aqueduct, rail lines and roadways connected Hastings residents to New York City, and city residents to Hastings. Early agriculture thrived because of its proximity to city markets. Waterfront industries developed with city infrastructures and consumers in mind. Immigrants came through the city to Hastings looking for work. Elites from the city built summer country estates and also permanent residences, planning to travel into the city for work. As train travel was electrified and became cheaper, middle-class commuters joined the local middle management and merchant families.

Hastings is a perfect example of what local resident and historian Roger Panetta describes in his 2006 book *Westchester: The American Suburb* when he calls for a more complex understanding of stereotyped suburbia. Neither exclusively upper-class like Scarsdale nor expansively conformist like the Levittowns, Hastings fulfilled its suburban identity in different ways. After all, Hastings was industrial as well as beautiful, so while there were sometimes class and ethnic tensions, Hastings never sought to exclude the working class or people of diverse ethnic and racial backgrounds but rather sought ways to create an inclusive community. Hastings residents had always appreciated clean air and the inspiration found in natural beauty. Progressive Era (1900–1920) attitudes placed an even greater emphasis on the morally cleansing power of a life of play and exploration in the natural world. More and more people began coming to beautiful Hastings for its child-friendly clubs, schools, and activities, rather than for agriculture or work. Hastings adults of all backgrounds began to think of themselves as raising a community of children. For example, Anaconda baseball players started the Little League, and local bar owner Dick Dunn used to treat his newspaper boy to a Coca-Cola when his team won or when he played a good game.

Today industry is gone, and Hastings is beginning to envision a new suburban identity. It will no doubt maintain its connection to New York City and its commitment to its children.

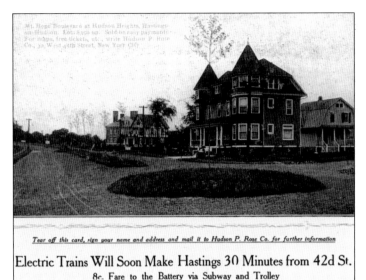

Tear off this card, sign your name and address and mail it to Hudson P. Rose Co. for further information

Electric Trains Will Soon Make Hastings 30 Minutes from 42d St.

8c. Fare to the Battery via Subway and Trolley

Lots $350.00 Up

Sold on easy payments

Trolley passes property

Sewer—Water—Gas

Schools and stores close at hand

Commutation 10½ Cents

Write name and address below and mail this card. We will send map, free tickets and full information.

Name...

Address...

..

This *c.* 1910 Hudson P. Rose Company promotional postcard for one of Hastings's earliest housing developments, Hudson Heights, shows the intersection of Mount Hope Boulevard and Rosedale Avenue. Advertised as a healthy location with attractively laid out boulevards, avenues, and streets, the development's main selling point was its proximity to stations both on the New York Central's soon-to-be-electrified main line and on the Putnam Division.

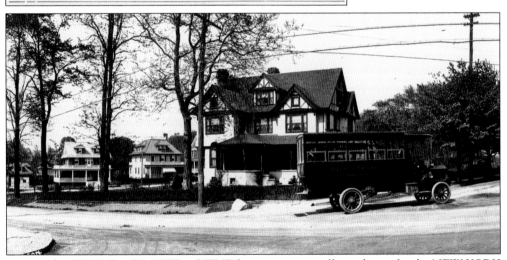

Promoted as "THE PLACE ATTRACTIVE for a permanent all-year home for the NEW YORK BUSINESS MAN," Riverview Manor offered residents train station shuttle service, shown here around 1912. The romantic design of the manor, which was purchased from the Minturn estate in 1906 by the Hastings Homes (National Conduit and Cable) Company, incorporated roads with park-like drives that followed the natural contours of the landscape and allowed magnificent river views.

Completed in 1929, Hastings's first apartment house, La Barranca ("The Ravine"), was situated on three acres in Cooks Woods above the ravine. On its main floor was Three Fat Cooks, a restaurant that advertised "Chicken and Waffles for $1" or just "Luncheon $.65." This colorful Mediterranean-style elevator building faced with yellow stucco had red sills and awnings. The lobby contained a mosaic panel depicting the adventures of Don Quixote.

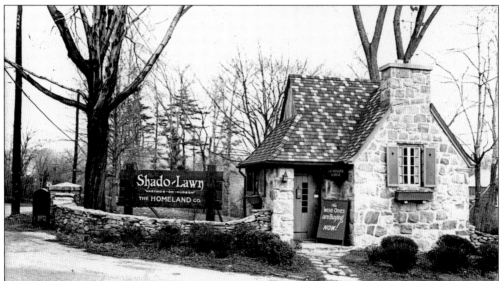

After the Homeland Company purchased the 30-acre Edward Moore estate for $200,000, it erected an office at the entrance to its new development, Shado-Lawn, shown here in 1932. Plans called for the erection of a little English village with houses constructed in stone, stucco, and half-timber and roads with typically British names like Derry Lane, Stratford Lane, and Windsor Road. The average price was $15,000.

This modest two-bedroom home on Clunie Avenue was built in 1940 by Charles Hegenauer Sr. on the Croydon model, pictured below, one of approximately 450 home designs available through Sears mail-order catalogs. Between 1908 and 1940, Sears, Roebuck and Company manufactured and sold over 100,000 pre-cut homes that were assembled on site. At least a dozen of them were delivered—and constructed—in Hastings. A typical Sears house consisted of over 30,000 separate parts and came with blueprints and a detailed construction manual. Hegenauer's construction notes reveal that materials were delivered on a staggered basis, as they were needed, over three months. In Hastings, Sears supplied suburbanites with affordable, quality construction. (Courtesy of John Wiley & Sons, Inc. Cole Stevenson, Katherine, and Jandl, H. Ward. *Houses by Mail.* Washington, D.C.: National Trust for Historic Preservation, 1986.)

THE CROYDON

The Croydon will give you and your family a spanking new outlook—fresh and inspiring as the spring of the year. It will prove to you that you can have a small house, absolutely modern, without a single trace of faddishness—and that it can be really impressive, too.

Details and features: Five rooms and one bath. Brick exterior; side porch with paired columns.

Year and catalog number: 1939 (13718)

Price: $1,407

The first state-of-the-art model homes of Waverly Estates, pictured here as they look today, were built on James Street in 1957. The house on left was called the Donray and was priced at $24,500. The larger model, the Waverly, sold for $27,000. A total of 36 homes were built on quarter-acre lots on Tompkins Avenue, James and Bevers Streets, and newly created Crossbar and Jordan Roads.

This ranch-style house was constructed in Riverview Manor after World War II on a lot next to its 19th-century Dutch Colonial neighbor. With almost all of the previously open areas in the village developed by the mid-1960s, houses in Hastings were often built on small lots between older houses, lending an eclectic look to many of Hastings's long-established neighborhoods.

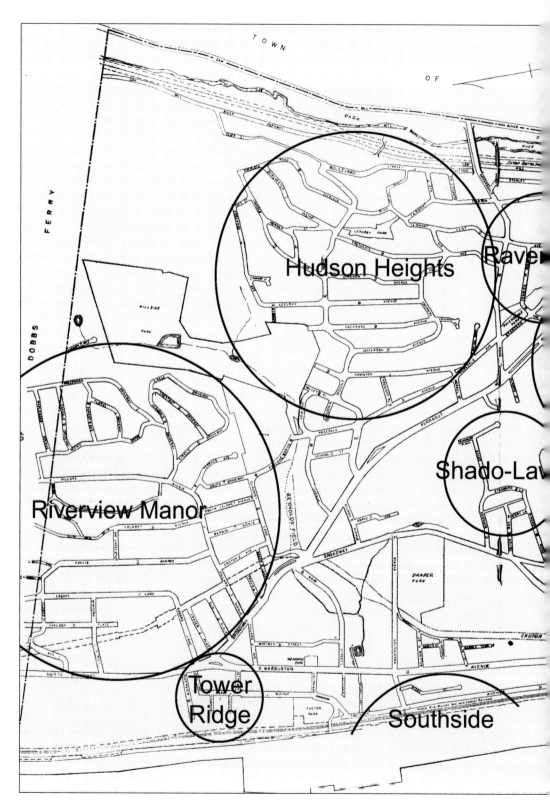

Hudson Heights

Rave

Riverview Manor

Shado-La

Tower Ridge

Southside

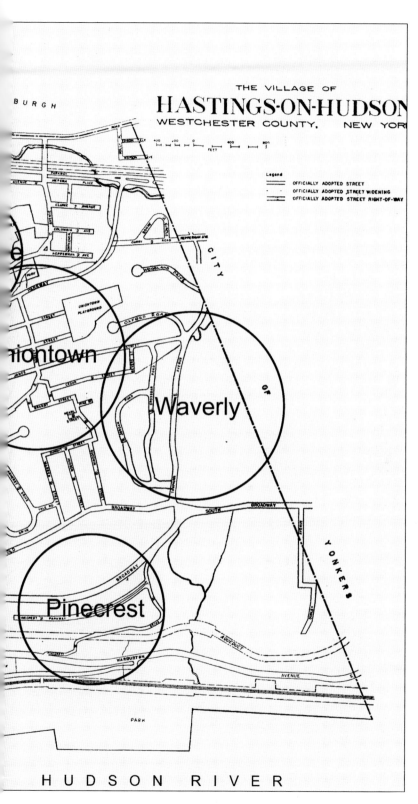

BURGH

Legend
≡≡≡ OFFICIALLY ADOPTED STREET
–·– OFFICIALLY ADOPTED STREET WIDENING
≡–≡ OFFICIALLY ADOPTED STREET RIGHT-OF-WAY

Waverly

niontown

Pinecrest

C I T Y O F

Y O N K E R S

HUDSON RIVER

This map of
the village of
Hastings-on-Hudson,
adapted from one
in the Hastings
phone directory
of 1963, shows
the approximate
locations and
boundaries of some
of the neighborhoods
mentioned in
this and in other
chapters. Most
neighborhoods were
not developed in
specific eras with
a uniform design
but evolved over
long periods of
time—decades, even
centuries—and their
varied architectural
styles reflect this.

117

Members of the Little League Lions, surrounded by family and friends, are pictured here rooting for their team in 1955. The Hastings Little League was established just three years earlier by several workers at Anaconda Wire and Cable Company who devoted a good deal of their free time to managing and coaching. Mill supervisor George Rusnak, the Lions' manager, can be seen top right.

A father and his two daughters are pictured here on Main Street running in Hastings's 1985 Turkey Trot. A popular annual event for families since 1977, the 10-kilometer race and the one-mile fun run continue to take participants over a hilly course through Hastings. Today the event is known as the Terry Ryan Run, in memory of a young and much-loved Hastings's native. (Photograph by Su Ruh.)

The Hastings Library, founded in 1913, did not have a home of its own until 1966 when this library building, set in Fulton Park with dramatic Hudson River views, was dedicated. By 2001, extensive renovations included an enlarged children's section, doubled seating capacity in the Orr Community Room, increased accessibility, and wiring for the digital age.

Boys are pictured here in 1981 fishing in Sugar Pond, which is located in 50-acre Hillside Park. Formerly known as the Duck Pond and likely created in the 1830s, Sugar Pond continues to be popular for fishing, ice-skating, and bird watching. The "warming shed" at the photograph's center was staffed as late as the 1970s by an attendant who kept the potbellied stove going on skating days.

First proposed in 1959, a community pool, pictured here with tennis courts in the background, finally opened in abundantly wooded Hillside Park in the spring of 1965. At that time, a family paid $45 to join for a season, an individual paid $25. In 1984, the year this photograph was taken, the pool was dedicated to Julius "Butch" Chemka, a popular pool director who died at an early age. (Photograph by Seth Harrison.)

Two children have fun at the playground, around 1990, in MacEachron Waterfront Park, Hastings's first park on the Hudson River. Named after a former mayor who obtained the state-owned land for the village, the 1.3-acre park, with several picnic tables and benches facing the river, opened in 1986. In 1998, the white Robison Oil shed in the photograph's background became the upscale Harvest-On-Hudson restaurant with spectacular river views.

A family is pictured here bicycling in 1984 on the grassy, tree-lined, Old Croton Aqueduct Trail in Hastings. Designated as a hiking and cycling trail by its managers, the New York State Office of Parks, Recreation, and Historic Preservation, the 26.2-mile trail provides magnificent views across the river to the Palisades as it passes north to south through Hastings.

The mile-long Rowley's Bridge Trail, dedicated in 2001 and still a work in progress, is located parallel to the Hudson River on property once owned by the Rowley family. Created by village naturalist Fred Hubbard and volunteers with village support, the trail extends from Southside Avenue south on a fairly level path from which the Hubbard Trail Extension climbs to Warburton Avenue opposite access to the Old Croton Aqueduct Trail.

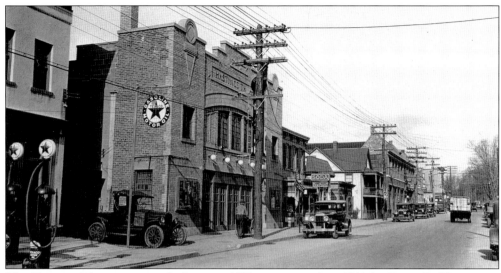

The Hastings Theater, pictured above in 1929, was erected in 1921 by Foster L. Hastings, a local architect and builder. There was great excitement when the village's first movie theater opened with the film *The Mark of Zorro* starring Douglas Fairbanks. Attending the opening were, among others, Billie Burke, Flo Ziegfeld, and the Zinsser family. The price of admission was 35¢ for adults and 25¢ for children. When the theater finally closed its doors in 1977, the reason cited was a decline in patrons, who by then were watching more television and traveling to "multiscreen" theaters beyond the village center. In 1983, the fine old art deco theater was converted to Moviehouse Mews, pictured below in 1987, an exterior mall containing six small shops that catered to an increasingly affluent Hastings's population.

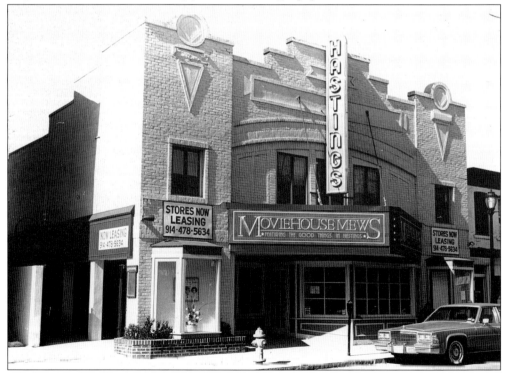

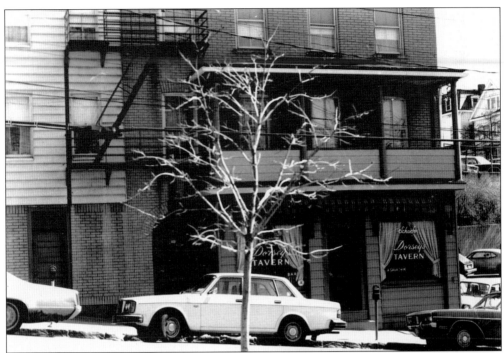

Dorsey's Tavern, located on Southside Avenue, is pictured above in 1981. Described by a *New York Times* restaurant reviewer as "an old, dusty bar," Dorsey's Tavern was one of what were at one time some 30 saloons, taverns, and bars in Hastings that catered primarily to shift workers at the Anaconda plant. When Anaconda closed its doors in 1975, these taverns suffered and most eventually closed. In 1993, Dorsey's Tavern was transformed into Maud's Tavern, a bright, contemporary pub offering American cuisine with "international flair." Outdoor dining at Maud's Tavern, pictured at right, soon became an option for patrons, many of whom were New York City commuters able to walk there directly from the train station across the street.

After a five-year-long battle, Hastings got its first "super market" in 1960, an A&P shown here in 1981, located in the former gardens of the Chrystie estate on the corner of Main Street and Broadway. Opponents of the large "chain store" argued it would destroy the village's character. Supporters countered that Hastings must keep up with modern suburban needs.

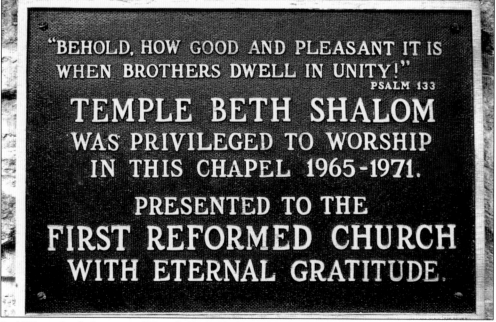

In 1971, at the dedication of Temple Beth Shalom's first building in Hastings at 740 Broadway, a plaque, pictured above, was presented to the First Reformed Church in gratitude for its hospitality during the temple's early years. Now able to attend a synagogue where their children could be educated about Judaism, increasing numbers of Jewish families moved to Hastings. In 1992, the first synagogue was replaced by a new structure.

124

To make it easier for people who work in Hastings to live there, an affordable housing policy was adopted in 1997. Shown here is one of the first two "workforce housing" residences in Hastings, each with a rental unit, built on Warburton Avenue on a steep slope overlooking the Hudson River and sold in 2003. A 14-unit workforce rental complex, also on Warburton Avenue, is scheduled to open in 2008.

The enlarged James Harmon Community Center opened on Main Street in Hastings in 2007, replacing the 1948 Youth Center at the same site. Technologically up-to-date and handicapped accessible, the new building, which boasts the largest community meeting space in the village, is a bustling center of activity for youngsters, seniors, village committees, and numerous civic groups.

The closing of Anaconda Wire and Cable in 1975 opened up for Hastings the possibility of regaining its entire 40-acre waterfront. While progress toward this has been slowed by the toxic pollution the factories left behind, a settlement between concerned parties was reached in 2003, and clean up is now underway. Shown here is a drawing of one proposed plan for reclaiming the north end of the waterfront as an extension of the existing downtown. This plan, which incorporated the ideas generated in 2000 at village resident "workshops," included a mix of residential and commercial uses, parks, restaurants, a boat dock, and a promenade—all with stunning views of the Palisades across the river. While debate continues about the right balance of elements in the mix and whether or not to retain some existing structures as a reminder of Hastings's industrial past, like an Anaconda building and the water tower pictured here at left, a revived riverfront will open up exciting opportunities for Hastings's future.

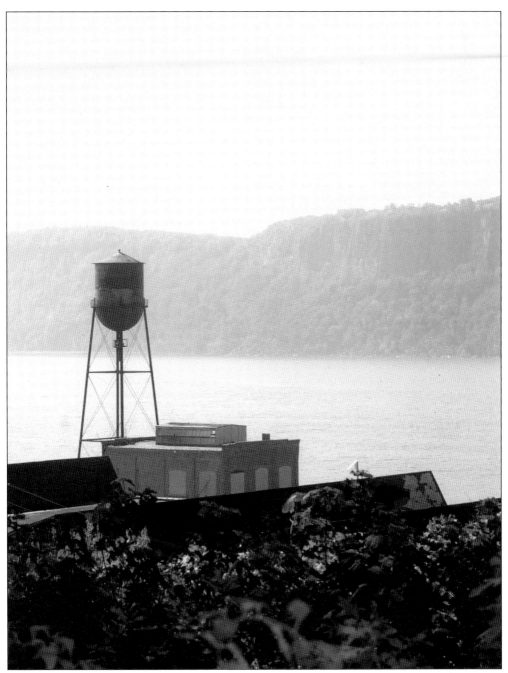

The Anaconda water tower has been a Hastings landmark for many years. As the vacant waterfront buildings are gradually demolished, the tower continues to tell boaters and anyone driving east across the Tappan Zee Bridge on a clear day, "there is Hastings." This recent photograph by Paul Duddy captures the iconic saw-tooth roof on one of the old factory buildings set against the river and the Palisades, a quintessential Hastings view.

ACROSS AMERICA, PEOPLE ARE DISCOVERING SOMETHING WONDERFUL. *THEIR HERITAGE.*

Arcadia Publishing is the leading local history publisher in the United States. With more than 3,000 titles in print and hundreds of new titles released every year, Arcadia has extensive specialized experience chronicling the history of communities and celebrating America's hidden stories, bringing to life the people, places, and events from the past. To discover the history of other communities across the nation, please visit:

www.arcadiapublishing.com

Customized search tools allow you to find regional history books about the town where you grew up, the cities where your friends and family live, the town where your parents met, or even that retirement spot you've been dreaming about.